WILD BIRD PHOTOGRAPHY

WILD BIRD PHOTOGRAPHY

Tim Gallagher

Lyons & Burford, Publishers

For Rachel

Printed in Hong Kong

Design by Laura Joyce Shaw

Line illustrations by Manuel F. Cheo

10 9 8 7 6 5 4 3 2 1

Library of Congress Cataloging-in-Publication Data

Gallagher, Tim.
 Wild bird photography / Tim Gallagher.
 p. cm.
 Includes bibliographical references and index.
 ISBN 1-55821-310-4
 1. Photography of birds. I. Title.
TR729.B5G35 1994
778.9′32—dc20 94-20794
 CIP

CONTENTS

▲▼▲▼

v

Introduction

I'll never forget the first time I set out to photograph a bird in the wild. It was the mid-1960s and I was a sophomore in high school. Luckily for me, my school had an excellent photography program, with a complete black-and-white darkroom and cameras we could take home.

On this pleasant spring morning, I set out on my bicycle (I was too young to drive) and pedaled nearly twenty miles to a golden eagle nest I'd known of for a couple of years. A game bag hung heavy around my neck; inside was a hefty Speed Graphic press camera, a light meter, and enough 4 × 5 sheet-film plates to take half a dozen shots or so. The down side of my school's photography program, you see, was that they only had large-format cameras for us to work with. Don't get me wrong. They were great cameras, excellent learning tools; but they weighed a ton.

After riding my bike all that way, stopping frequently to switch the bag from one shoulder to the other, I was exhausted. And I still had to hike five miles up and down hills, where beef cattle, coyotes, and rattlesnakes roamed, to reach the old sycamore tree where the eagles nested. As I topped the last hill before "eagle valley" I flopped down beside a dusty cow path and tried to catch my breath. A group of Herefords bellowed nearby, while in the distance a raven croaked hoarsely.

I could see the huge pile of sticks at the top of the tree and the shape of two eaglets, even without binoculars; I didn't bring any because I

was already too laden with equipment. I also didn't bring any climbing spurs or rope. I knew I'd have to climb from branch to branch, and to shinny in some places where there were no branches, while carrying all that heavy equipment.

I must have looked like a zombie as I stumbled the last two hundred yards down the hillside, across the valley, and up to the eagle tree, which stood at the opening of a small gorge. The adult eagles were nowhere in sight. They were probably out hunting or soaring on thermal updrafts. Their young were fairly well developed by now, so they could leave them for hours.

I remember how high up the nest looked from below. And I was already dog tired. What if I had trouble on the way up? What if I got stuck in the tree? What if I fell and lay injured for hours or days? No one knew I was there. Doubts filled my mind. For a moment I was tempted to give up and trudge back to my bicycle.

I think if I had taken that easy road, I never would have tried to take another bird picture. Instead, I slung my camera bag over my shoulder, pushed it around to my back, and grabbed the lowest branch. Heaving myself up with all my might, I reached for the next branch and the next, totally committed to climbing that tree or dying in the attempt. I may have come close to doing just that. Halfway up the tree, my arms ached and the bitter taste of adrenaline filled my mouth. I kept on. I stopped at a fork three-quarters of the way up and caught my breath. But the muscles in my arms and legs still felt like rubber.

But the worst part came as I reached the bottom of the nest. I saw that I'd have to reach far from the trunk to grab one of the large limbs supporting the nest, then pull myself up and wrap my legs around it. The first time I tried, my feet slipped, leaving my legs dangling in space as the heavy camera bag smashed my back. I knew I was at the end of my strength, but I had to try again. I hoisted my leg up and slipped again. Finally I got a foot and then a leg around the limb, and with all my might pulled myself around to the top of it. I lay there breathing deeply for a long time, until the loud hiss of an eaglet broke my reverie. It was the first time I'd thought of the birds since I'd begun climbing the tree.

The eaglets seemed enormous—much bigger than I'd expected. The two birds, a male and a female, were fairly well feathered, but still a

couple of weeks or so from fledging. They bent toward me with beaks agape, thrusting their great wings forward, trying to be intimidating.

I stepped right down into the nest, among the jackrabbit and ground squirrel carcasses. In the midday breeze, the huge nest swayed widely, making me giddy and a little sick. I pulled the camera up in front of me. I took a light-meter reading and made the proper settings on the camera. After sliding the film holder into the back of the camera, I removed the protective sheet and then fired my first shot. And I continued methodically through the motions until all six sheets of film were used up.

I can't remember much about how I got down from the tree—it was probably just as hard as climbing up. And I don't remember much about the long hike back to my bicycle, or the ride home. I must have been on full autopilot by that time. Anyway, I made it back and developed the film.

The pictures were okay. I'd like to say that they were the greatest eagle shots I've ever seen. I'd like to say they launched a distinguished career and from that point on my future was assured. If I did, I'd be lying. They were okay and I even had one or two of them published eventually. But the experience of taking the photographs is what made the whole thing worthwhile, because it proved to me: I can do this. It's something I've never forgotten.

This Introduction is a roundabout way of saying that bird photography can be a lot of hard work. It involves long periods of boredom and extreme physical discomfort. But in those rare moments when everything comes together for you, you'll find a degree of excitement in bird photography that's more intense than many people experience in their entire lifetimes. And you'll also have pictures, the most wonderful souvenir of your time in the field. If bird photography sounds like an activity that would appeal to you, read on. This book will provide the basic information you'll need for getting started.

I'm assuming that most of you reading this book already have a rudimentary knowledge of photography and I have therefore omitted much of the most basic information on camera function—what is an f/stop; what is a light meter; what is a shutter release cable. For anyone completely new to photography, I suggest taking a photography class at a local community college or reading some of the books I've recommended in the Appendix. With all the recent improvements in camera

technology, anyone can master the basics of photography in a relatively short time. Once you have a feel for how your camera equipment functions, you'll be ready to try the techniques included in this book.

Though I may take it for granted that you know how to use a camera, I do not assume that you know everything about birds. One of my goals in writing this book is to raise photographers' awareness of bird behavior. To be really good at bird photography, you need to understand birds—how they communicate with other birds, the way they feed, their habitat requirements—and you need to feel empathy for them. The best bird photographers are naturalists first.

I've spent most of my life studying birds, as a bird watcher, a falconer, and a field assistant in numerous bird research projects, and the knowledge I've acquired has been a great asset in my bird photography. Developing an understanding of birds takes time, but there are shortcuts you can take to speed up the learning process. I've provided tips on how to learn birds' songs and calls, how to interpret behavior, and how to take advantage of the worldwide network of bird watchers.

Probably the most valuable thing about this book for most people will be the commercial aspect. It's nice if you can make back some of the money you've spent on film and equipment (or even turn a profit) by selling your photographs. It's also a good way to share your work with the public. Many nature photography books tell you how to take a better picture; few say what to do with it once you have it—how to target specific magazines, how to package your submission effectively, what magazines are looking for. I hope to fill that gap. I've been a journalist for over fifteen years—both as a freelancer and as a staffer—and I've been a photographer even longer. I've worked for several magazines, including *Western Outdoors*, *WildBird*, and *Living Bird*, and also a number of newspapers. Since I'm a photographer, I always ended up being the one who selected photographs and shot most of the in-house photographs for these publications. I've seen the business from both sides and I can offer some useful insights on how to catch the eye of a picture editor.

Even if you have no intention of selling your photographs—you just want to entertain your friends, family, and bird-club members with slide shows—this information will be useful. It will help you to raise your work up to professional standards. Some of the most interesting

and artistic nature photography in the world appears in magazines, books, and calendars. By striving to bring your work up to a publishable level, it can only boost your skill in the fascinating field of bird photography.

1

TOOLS OF THE TRADE

THE FIRST QUESTION most people ask when they decide to take up
bird photography is: What kind of equipment do I need? So many
different kinds of cameras and lenses are available, all loudly touted by
company advertisements. How can I be sure I'm getting the best equip-
ment for my purposes?

It's true. It isn't easy to select equipment. New products appear on
the market constantly, and each one seems like the answer to your prob-
lems. It's easy to spend a lot of money on this hobby. I always encourage
people to spend less and try to get more use out of the equipment they
have. If you read this chapter carefully and take time to analyze your
own particular needs in bird photography, you shouldn't have much
trouble narrowing your search down to a few equally good products.

CAMERAS

The first thing to consider when choosing a camera is portability.
Though some bird photographers take almost all of their pictures at
home and aren't bothered by the weight and bulk of their equipment,
most of us spend a lot of time trudging up and down hills and through
marshes. In these situations, the smaller and lighter your camera is
(within reason), the better off you are.

This pretty well eliminates large-format cameras. Though they do

take stunning pictures (just look at Ansel Adams' work) and can produce enormous enlargements with minimal loss of detail, the equipment is too heavy and bulky for effective bird photography. If you read my Introduction, you know that I began my bird photography in high school using an old 4 × 5 press camera. It gave me a good grounding in the fundamentals of photography (and helped develop my biceps), but it's not an experience I'd like to repeat. Since interchangeable telephoto lenses were not an option with that camera, I had to hide in a blind to get closeup shots of birds. Sometimes I waited hours for birds to come near. Then, after finally snapping a picture, I had to hassle changing the sheet film holder before I could take another shot. As often as not, the bird I was photographing took that opportunity to continue its migration.

For many years, medium formats, such as 2¼ × 2¼, were the sizes preferred by most book and magazine publishers. Fortunately, things have changed. Now virtually all publishers accept 35mm and many prefer it. In fact, 35mm transparencies are now the standard for most magazine photography. This has been a welcome change for wildlife photographers. Medium-format cameras have a number of disadvantages. They are larger and heavier than 35mm cameras, the film is more expensive, and each roll of film holds far fewer shots than the standard 36-exposure canister of 35mm film. Large- and medium-format cameras are now used mostly for studio photography.

Another format that should be rejected by serious bird photographers is 110. Though a 110 camera may produce acceptable snapshots of a family outing to Disneyland, the image size is too small to produce professional-quality enlargements. In addition, for those who intend eventually to sell their photographs, publishers will not even look at transparencies smaller than 35mm.

For a variety of reasons—comparatively low film price, light weight of equipment, acceptability by publishers—35mm is the film size of choice among the majority of professional wildlife photographers. Another plus for this format is that most of the research and development carried out by major camera manufacturers is aimed at improving their 35mm cameras—by developing better exposure meters, improved lenses, new technologies such as autofocus, and lighter, stronger camera bodies.

Of the 35mm camera types on the market, the single-lens reflex (SLR) is the best choice for bird photography. The cameras are lightweight and compact. Most models accept a wide array of interchangeable lenses, from ultrawide-angle fisheye lenses to super telephotos. The SLR is distinctive in that the image travels through the lens, then bounces off a mirror in front of the film, and up through a prism that deflects the image once more and directs it to the eye of the photographer. At the instant the shutter release is pressed, the mirror flips up and a focal-plane shutter curtain flies across, allowing light to hit the film for an instant; then the mirror snaps back into place. This unique design allows you to see the exact image that will appear in the photograph, which makes composing a picture and focusing very easy and accurate.

A number of companies manufacture acceptable 35mm SLR cameras. But taking a look at the company's reputation, special assets, available equipment, and price structure, as well as the overall look and feel of a camera will point out the best choices. One thing to look at when shopping for a camera is the type of lens mount. In the past, many SLR cameras used screw-mount lenses, which were difficult and time consuming to change, and there was always the chance that you could cross-thread the lens if you rushed it, resulting in an expensive repair job. Thankfully, most SLR cameras now have "bayonet mount" lenses. The touch of a button and a quick twist of the wrist is usually all you need to change a lens. But some bayonet mounts are better than others, so it's worth shopping around to find out what works best for you.

Most major camera brands—Nikon, Canon, Minolta, Olympus, Pentax, and others—have 35mm SLR cameras suitable for bird photography. A major consideration to be taken into account before you buy a particular brand, however, is the range of optional equipment available. Does the manufacturer offer an extensive line of lenses for use in a variety of situations, or does it have only a handful of optional lenses for its cameras? After all, you're buying more than a camera; you're buying into a lens system. You want to get into a system that can grow with you as your skills or special needs change. The fact that the majority of professional photographers use either Nikon or Canon equipment is largely because the two companies produce extensive lines of interchangeable lenses.

Be sure to get a camera with a built-in exposure meter. That way you won't have to carry a separate hand-held light meter to determine the correct exposure. Automatic exposure control is also a handy feature, leaving you free to focus and compose your pictures without constantly having to adjust your aperture setting or shutter speed to compensate for changing light conditions.

If you do buy a camera with automatic-exposure control, make sure that the exposure can also be set manually. Some situations in nature photography can fool an automatic-exposure system. Taking properly exposed pictures of birds in flight is particularly hard for some automatic systems. The meter takes a reading off the brightly lit sky in the background rather than off the dark-colored bird you're photographing, and you end up with a silhouette. In this case, it's better to take a meter reading from another object with a color or reflective quality similar to that of the bird—the ground, some foliage, rocks—and set the exposure manually.

Some cameras have "matrix" exposure-metering systems, which analyze diverse lighting conditions, automatically compensating for bright backgrounds and other difficult lighting situations. My Nikon F4S has this feature and I've had excellent results using it in a wide variety of lighting situations—backlit subject, snow, bright sun. But it's also available in the Nikon N8008S, which costs half as much as the F4S.

Interchangeable focusing screens are another handy feature to have on an SLR camera. Many stock focusing screens come with a split-image rangefinder in the center of the viewfinder. The two halves of the image move together or apart as you turn the focusing collar on your lens. When the images are perfectly aligned, your subject is in perfect focus. But these focusing devices can actually be a nuisance, especially if you're using a telephoto lens. The split image becomes a dark spot at the center of that image when you use most long lenses. With practice, it's quicker and easier to focus by eye, using a blank focusing screen. The first thing I do when I buy a new camera is to replace the stock focusing screen. I sometimes use a screen that has a grid of horizontal and vertical lines etched on it. This makes it easier to line up the horizon properly in my pictures.

Motordrives are extremely useful in bird photography. Although

you tend to shoot up more film if you use one, a motordrive eliminates some wasted motion and time. While photographing a restless bird, time is of the essence. Even if you don't need a motordrive at present, it's a good idea to buy a camera body that will accept an optional motordrive in case you need one in the future. Though motordrives are somewhat noisy to use, they rarely scare birds away. More often than not, the sound of a motordrive only snaps a bird to attention, causing it to pause for a second—an excellent time to squeeze off a couple more photographs.

Many cameras now have built-in motordrives or autowinders. In the past, I preferred camera bodies that had removable motordrives so that I'd have the option of advancing the film manually while photographing a nervous bird that might be scared off by the sound of a motordrive. It was also nice to be able to take off the motordrive and leave it at home on those occasions when I had to pack lightly. I must say, however, that some of the latest cameras have whisper-quiet motordrives—actually quieter than most manual-advance cameras—which are very light and compact. Try out a few models at the camera store, comparing speed, efficiency, and quietness—then decide for yourself.

I'm often asked about autofocus cameras. Autofocus was something I resisted for several years, but since I bought my F4S I find I'm using it more and more. It's been especially useful for taking quick shots of shorebirds running up and down the beach. Autofocus has not been that useful to me for flight photography. I've been taking flight shots of birds with non-autofocus equipment for long enough that I'm capable of focusing my lens fairly quickly and accurately by hand, using the "follow focus" technique described in Chapter 4. Photographing flying birds with an autofocus camera requires another set of skills entirely. You must keep the focusing sight at the center of the frame right on the bird to keep it in focus. If the focusing sight slips off the bird, the lens instantly focuses to infinity, turning a close-flying bird into a formless blur. Though I have taken some excellent flight shots using autofocus cameras, I don't think my success ratio went up at all with this equipment. Again, try out autofocus and decide for yourself. Some camera stores will rent equipment if you want to field test an autofocus camera before making an expensive purchase.

The final consideration in the choice of a camera is the overall

ruggedness and durability of the product. Let's face it: Any camera equipment used for photographing wildlife does tend to get knocked around a little in the field. If you really get into this as a hobby or profession, you'll probably be slogging through marshes, climbing trees, or crawling through dense vegetation before you know it. Take a close look at the camera you intend to buy. Does it really look like it will hold up under field conditions? You know better than anyone else the kind of abuse your camera is likely to face.

Many cameras on the market now are made primarily of plastic. That in itself is not necessarily a bad thing—some high-impact plastics are quite durable—but I think a camera needs to at least have a metal interior framework to make it tough enough for bird photography. If you're in doubt, look at product brochures for the camera you're thinking of buying. They often list construction materials. Also, and more importantly, try to find a product review of the camera in *Consumer Reports* or one of the many photography magazines. You can find back issues of these publications and a reference list of articles at most public libraries. If you take the time to do a little research on your own and talk to other photographers in the field, you should be able to find a camera that will fit your needs now and in the future as your skill in bird photography grows.

I got as close as I could with a 400mm telephoto lens to this great egret (opposite page) for a close-up portrait. The camera angle accentuates the S-curve of the bird's neck.

LENSES

It doesn't take long once you start photographing wild birds to realize how indispensable a good telephoto lens is. The 50mm so-called "normal" lens that camera stores push as standard equipment with most 35mm SLR cameras is great for taking shots of your friends, family, and pets, but as a tool for bird photography, it's seriously deficient. At the minimum distance that most wild birds will allow for your approach, even a brightly colored bird such as a cardinal will show up as little more than a tiny crimson dot in your picture if you photograph it with a 50mm lens. To bring that dot up closer to frame-filling size, you need heavier artillery.

Telephoto lenses in the 300mm to 500mm range are the best focal lengths for most bird photography, providing an acceptably large image without your having to stalk impossibly close to a wary bird. But a

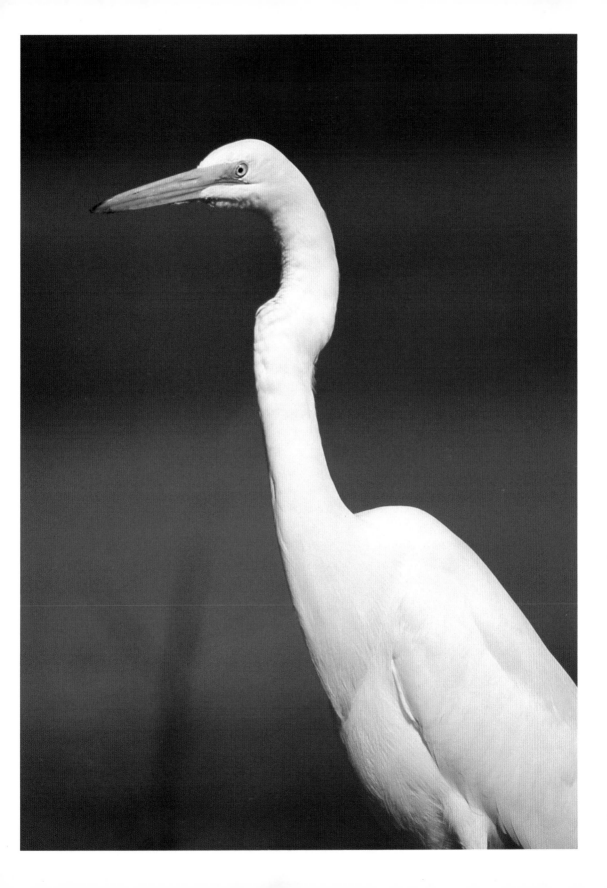

long lens is not a complete cure-all for all the problems inherent in photographing birds. Telephoto lenses come with a number of problems of their own that you'll need to deal with. For one thing, you may find that a lot of your telephoto shots are blurred from camera movement. Just as ten-power binoculars are more difficult than seven-power to hold steady enough for comfortable viewing, long telephoto lenses are more sensitive to movement than less powerful lenses. The high magnification power of a telephoto lens intensifies the negative effects of any motion or camera vibration. Thus a photograph that might have been razor sharp taken hand-held with a 50mm lens might be badly blurred when taken hand-held with a 400mm lens, even though you used the same shutter speed.

Another disadvantage of telephoto lenses is that most of the affordable ones are relatively slow, usually f/5.6 or even slower. The "speed" of a lens is determined by its maximum wide-open aperture setting—the smaller the f/stop number, the larger the aperture and the more light passing through the lens—thus an f/4 lens gathers an entire f/stop more light than an f/5.6 lens. This provides a brighter image in your viewfinder, making it easier to focus in low light, and more importantly, allows you to use a faster shutter speed when you take a picture. But to provide that extra light-gathering ability, the camera manufacturer has to use a larger front element on the lens, which adds significantly to the weight and purchase price of a lens.

To compensate for a slow lens, you have to use a slow shutter speed—under the exact conditions when you need a fast shutter speed most to eliminate blurring from camera vibration. The most affordable answer is to always use a tripod or other solid support with your telephoto lens. Or you could buy a superfast telephoto lens, such as a 400mm f/2.8, but they're heavy, awkward to carry around the field, and incredibly expensive—over $5,000. You'd have to sell quite a few bird images to make up that amount.

I'm constantly amazed to see how many photographers, many of them amateurs, are willing to spend that kind of money on a lens. Visit the Anhinga Trail at the Everglades almost any day of the week and you'll see a staggering array of high-priced lenses, most of them focused on the same great blue heron, white ibis, or anhinga posing next to the path. I think it's a mistake to spend that much on a lens, unless

you're already a well-established professional photographer, bringing in a fair income. In that case, at least you can get a tax write-off for the lens.

If you're just starting out and you're at all intent on making a profit or at least breaking even with your bird photography, buy a top-quality 400mm f/5.6 lens, preferably made by the same company that manufactured your camera. Look for a lens made with "ED" (Extra-low Dispersion) optical glass. In a telephoto lens without ED glass, you're more likely to have problems with color fringing and lack of clarity in your pictures. You may have noticed color fringing if you've ever looked at a bird through inexpensive binoculars or telescopes—it usually looks like a purple (or another color) outline around the bird. If your telephoto lens causes color fringing, it will show up in your photographs.

Internal focus is also an important feature in a telephoto lens. It's easy to see the difference between an external- and an internal-focus lens. With an external-focus lens, the lens barrel gets longer or shorter as you change the focus, visibly moving the front lens element back and forth. With internal focus, lens elements inside the lens move to determine the focus; the barrel length stays the same. Grit and moisture can't get inside an internal-focus lens as easily, and it usually takes fewer turns of the focusing collar to go from minimum close focus to infinity, so focusing is quicker and easier.

For my Nikon camera, I can buy a 400mm f/5.6 lens with ED glass and internal focus for under $2,000—a far cry from the $5,000-plus I would have to spend for a 400mm f/2.8 to gain a mere two f/stops of light. The slower lens can provide the same great image as the f/2.8. The only negative factor, as I've said, is that you must use a slower shutter speed to expose the film properly. A 400mm f/5.6 lens is incredibly portable—small enough to fit inside my camera bag along with a couple of camera bodies and some shorter lenses. Try doing that with a 400mm f/2.8 lens.

People often ask me my opinion of mirror lenses—those short, wide lenses that use a powerful curved mirror in the back to magnify the image, which is then bounced back to a tiny mirror at the front of the lens, which in turn bounces it to the film plane of the camera. I don't care for mirror lenses, especially for bird photography. I realize that

they are compact, reasonably priced, and often powerful—mirror lenses are usually 500mm, which translates to 10×—but they invariably produce doughnut-shaped halos of light in your pictures wherever there's a highlight. Taking a picture of a lake glistening in the sunlight, you might end up with something that looks like a bowl of shining Spaghettios. That might be a nice effect to use once or twice, but you get tired of it pretty quickly. Also, these lenses are slow—usually f/8—and they don't have adjustable apertures.

One shortcoming of many telephoto lenses is that they have a long minimum-focus distance. With some of them you must be over twenty feet away from your subject to get it into focus. A tiny bird, such as a hummingbird or a wren, will produce an unacceptably small image on the film at this distance. Some photographers place one or more extension tubes between the camera and the lens to overcome this problem. This greatly reduces the minimum-focus distance of a lens. Unfortunately, there is also a reduction in the amount of light reaching the film when you use extension tubes. You must use a wider aperture opening (smaller f/stop number) or a slower shutter speed to compensate.

I learned long ago as a fly fisherman that there are tradeoffs in anything you do. A gossamer-thin tippet at the end of your fly line gets you many more strikes from hungry trout that can't see any line attached to your fly, but it's much harder to land the fish because the line breaks so easily. With fly fishing, you compensate by playing the fish carefully until it tires out before you try to coax it into your landing net; with bird photography, you always use a tripod or other solid support when using a telephoto lens.

Many bird photographers use teleconverters to boost the power of their telephoto lenses. A teleconverter is a small, additional lens element that you attach between your camera and lens to increase magnification. These are commonly available in 1.4×, 2×, and 3× powers. As with almost everything else in photography, boosting the power of your lens with a teleconverter has some drawbacks. When you use a teleconverter, you'll notice some image degradation in your pictures— a little less sharpness, more contrast, less detail—particularly with a 3×. In addition, teleconverters cause a significant reduction in the amount of light reaching the film (a 3× teleconverter reduces the light by a full three f/stops). The 1.4× teleconverter is the one preferred by

most professional wildlife photographers. It boosts the power of a lens by forty percent, while losing only one f/stop of light. With a 1.4× teleconverter attached, a 400mm f/5.6 lens becomes a 560mm f/8 lens. If you decide to use a teleconverter, I advise you to buy only those that are designed for your particular lens. Though they're significantly more expensive than generic teleconverters, they're worth it for the image quality they provide. Image degradation is quite pronounced with inexpensive teleconverters.

Though I recommend buying the slower, less expensive f/5.6 if you opt for a 400mm lens, I do not recommend buying an inexpensive, off-brand telephoto lens. Considering the high cost of film and processing (and also of travel if you must go a long way to photograph birds), your telephoto lens is not the place to skimp. If you need to save money, you could buy a used camera body and still take some great pictures, but a poor quality telephoto lens may not even be capable of producing an acceptable image. Buy the best lens you can afford. With cheap telephoto lenses, you definitely get what you pay for. The bargain-basement 400mm lenses you can sometimes pick up for $100 are just about useless for bird photography, especially if you intend to sell your photographs at some point. In the competitive world of nature photography, you must have crisp images.

It's been frustrating for me, as an editor, to look at a photograph that was taken with an inferior lens. Such a photograph offers a teasing glimpse of the fine picture that could have been if the photographer had used better equipment. The composition is there; the bird's image is large in the frame. But on closer examination through a magnifying loupe, the flaws become apparent: a lack of crisp definition, an overall fuzziness to the picture, and perhaps some color fringing. Needless to say, a photograph like that is returned immediately to the contributor.

To take care of my other photographic needs—habitat shots, flocks of birds—I always carry a couple of zoom lenses, a 28–80mm and an 80–200mm. Each zoom lens is like having many different lenses rolled into one. The 28–80mm lens in particular goes all the way from a good wide-angle scenic lens, to a tight portrait lens. Zoom lenses also allow you to enlarge or reduce the image size without having to change lenses or move closer or farther away. These lenses, together with my 400mm, cover a wide range of distances and picture-taking situations,

and they don't take up much space. I had been dead set against using zoom lenses for many years, because they were never as sharp as prime fixed-focal-length lenses. Things have changed. Today's modern zoom lenses, at least those made by top camera manufacturers, are first rate.

ELECTRONIC FLASHES

Electronic flashes can be quite useful, even in daytime, for bringing out the vivid colors of a bird or adding a "catch light" to its eye. If you've never thought about how much that tiny glint of light in a bird's eye adds to a photograph, find a closeup picture of bird in a magazine and black out the catch light with a felt pen—you'll see how lifeless the bird looks.

Many improvements have been made in flash photography in recent years. You should be aware of them so you can buy a camera that takes advantage of all the latest technologies. One important consideration is the "flash synch speed" of a camera. If you take a picture using a faster shutter speed than the synch speed, you usually end up with a partially illuminated photograph and a frozen image of the shutter curtain caught in midstride as it passed over the film.

This sora was foraging in a dark, shallow ditch. An electronic flash adds a small glint of light to its eye. Without this "catch light," a bird will look lifeless in a photograph.

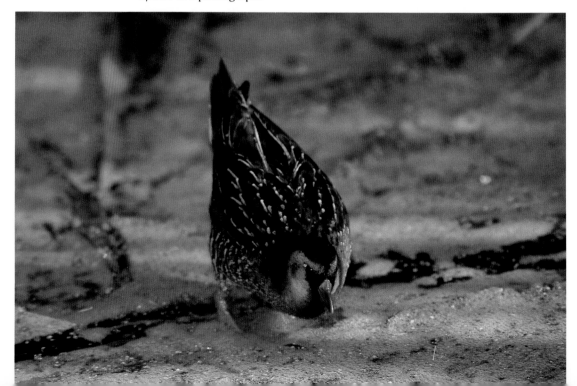

For many years, most 35mm SLR cameras had maximum flash synch speeds of only 1/60th of a second. This created a problem with outdoor flash photography on bright, sunny days, because 1/60th of a second was too slow a shutter speed to avoid overexposing the film or creating ghost images. Now, many cameras have flash synch speeds of 1/250th of a second—a vast improvement.

Another fantastic development is the fully automatic, dedicated electronic flash with "through-the-lens" (TTL) exposure control. With this kind of flash and camera system, the light of the flash bounces off the subject, and goes back to the camera; then a sensor at the film plane automatically turns off the flash when the perfect exposure is achieved.

An electronic flash is not, in my opinion, an indispensable piece of equipment for bird photography. Some people would debate this point. In fact, some photographers rely on elaborate lighting setups for all their bird photography. But multiple-flash photography has an artificial look to it that is not pleasing to me. Something about it always jumps out at me and says "this is a photograph." I'm sure that it's because the bird has another catch light in its eye for every flash used, and also because the image has less depth. When I look at a good shot taken with natural light, or with only one artificial light source, I almost forget for a moment that it is a picture.

I use a flash most often for the times when a bird might not have a catch light at all in its eye. For example, if a bird is backlit by the sun, that can produce a wonderful background in your picture, but the side of the bird that's facing you might be completely in shadow. A little fill flash can really improve a picture like that, adding a catch light to the bird's eye and a little more color and detail. To soften the artificial light, I often use a small soft box with my strobe. A soft box is a small attachment that you place over your strobe to diffuse the harshness of the light, and to produce softer shadows. You can find soft boxes at many camera stores or in mail-order photographic catalogs.

TRIPODS AND OTHER SUPPORTS

Many beginning bird photographers don't realize how important it is to have a good tripod. I rate a tripod as one of the most important items of equipment in bird photography. It's just about impossible to

take decent telephoto shots without a tripod. But some tripods are so rickety that they're not much of an improvement over hand-holding your camera. So don't skimp on this vital item of equipment. Buy the best tripod that you can afford.

Though dozens of tripods are available on the market, it's a good idea to stick with a proven brand. One of the best I've tried is Gitzo, a French brand that's popular with many photographers. I'm currently using a Gitzo 341 with a Studioball head, and it's just about perfect for my needs. But this setup is very expensive. In fact, the tripod costs over $400 and the Studioball head costs another $300. A less expensive alternative to the Gitzo is a Bogen 3021 tripod. I used one exclusively for several years, and took many good shots with it. These are good, solid tripods. And Bogen also sells an affordable ball-joint head, the 3055.

A ball-joint head is definitely the way to go for bird photography. These heads utilize a simple ball-and-socket joint that allows you to move the camera freely in all directions. When you find the camera angle you're after, you simply turn a knob or lever and the assembly locks, holding your camera firmly in place. I formerly used a tripod equipped with a fluid-head and a panning arm. It provided solid support and wasn't bad for photographing slow-flying birds, but for most situations with birds you need the quickness that a ball-joint head affords.

To minimize the pain of carrying a heavy tripod, camera, and lens around on my shoulder all day, I put foam insulation around the upper legs of my tripod. This is the same kind of insulation that you wrap around the water pipes in your basement to protect them from frigid winter temperatures. Some photography catalogs sell a fancier version of this padding for your tripod, but the kind you can get at the plumbing-supplies shop is just as good and much less expensive. I wrap the insulation with duct tape or camouflage tape to hold it in place. When I'm walking along, supporting the camera and tripod on my shoulder, it only takes a couple of seconds to flip it around, set it up, and start taking pictures.

If using a tripod is out of the question, for whatever reason, I usually opt for a monopod. A monopod looks like a tripod but, as the name implies, it has only one leg. With the monopod lowered to its minimum height, you can sit down with your legs crossed and hold your camera steady on a monopod. But it's never as solid as a tripod. I'd rather car-

ry the extra weight of a tripod around in the field than depend on a monopod for support.

I often use a rifle-stock-style shoulder mount with my telephoto lens for flight photography and also when I take pictures from a car. Though not nearly as effective as tripods, shoulder mounts are a vast improvement over hand-holding your camera. It helps if you can brace them against a car door, a tree, the ground, or another solid object. Some shoulder stocks have a threaded hole on the bottom that allows you to screw in a monopod or tripod for extra steadiness. You'll find them in photography magazines, equipment catalogs, and in some camera stores.

When I want to lie down flat on the ground with my camera, I usually set it on a beanbag. You can buy one of these ready made, but they're easy to make yourself. My current beanbag started out in life as a drab, brown throw pillow, about 1-foot square in size. I replaced the stuffing with dried beans from a grocery store and sewed it back up. The advantage of beans over cloth stuffing is that they mold easily around your camera and lens, offering fairly solid support. You can also drape them over your car's open side-window if you're taking pictures from a vehicle.

FILM

These days, if you want to sell your photographs to magazines and book publishers, you must shoot with color slide film. Publishers will rarely buy color prints, because they don't reproduce as well as transparencies. Several excellent films are available to choose from, each with their own strengths, weaknesses, and special properties. Try several kinds at first to see which film you like best. But once you find one you can work with, you should stick with it as much as possible. That way you'll get very used to the film and eventually you'll have an almost instinctive feel for what it can do in a given situation.

For many years I shot Kodak film exclusively, first Kodachrome 25—which has nice color and is very fine grained, but is a little slow for most bird photography—and later Kodachrome 64. With the latter film, I always set my camera's exposure meter at ISO 80, which I found produced a better exposed image than I'd have gotten if the meter had

been set at the film's official ISO rating of 64. Then Fuji came out with two excellent slide films: Fujichrome 50 and Fujichrome 100. The warm, luxuriant colors of these films seemed dazzlingly superior to the Kodak films. And since they are developed using the E-6 process, many local labs could process them in-house, sometimes in only an hour. Kodachrome always had to be sent away to be processed. Then Fuji went further and came out with Fujichrome Velvia 50, which is the most stunning-looking slide film I've ever used.

Fujichrome Velvia is more and more becoming the film of choice with nature photographers and the publishers who buy their work. In some ways, Velvia produces color that is snappier than real life. A muddy pond may come out a beautiful sky blue in your pictures. Some photographers have complained that this film is not giving an accurate image. I disagree. Though Velvia may enhance the color of a bird, it will not produce an image that is beyond the possible color range of the species you are photographing. And since so many publishers are clamoring for Velvia transparencies, I have no problem with using it. It's really no different from using a filter to make the clouds pop out more in a picture of the sky. I only regret that Velvia is so slow—ISO 50.

For flight photography and other situations requiring a faster film, I use Fujichrome 100 pushed one stop in processing—that is, I set my camera's exposure meter on 200 and then tell the lab to overdevelop the film long enough to double its effective ISO rating. This is a standard procedure and virtually every professional photography lab offers this service for an added fee. Pushing film does have a few drawbacks besides the extra expense—the pictures tend to have more contrast and to be more grainy than they would have been if they had not been pushed —but the results are definitely good enough to produce salable pictures. I've had excellent results pushing all three of these Fujichrome films. Be sure to mark any rolls of film that you intend to have pushed; otherwise you might forget to tell the lab and all your pictures on these rolls will turn out underexposed. I always write any special developing instructions on a piece of masking tape and stick it right on the film cartridge.

Several years ago Kodak came out with Kodachrome 200, a faster version of their popular slide film. I tried several rolls, but I was disappointed. It seems unacceptably grainy to me. I much prefer the look of Fujichrome 100 pushed one stop.

You might want to try out some Kodak Ektachrome. As with Fujichrome, this film is developed using the E-6 process. I don't happen to care for Ektachrome—it's a little too cold and greenish looking for my tastes. But some photographers like it.

Just when I'd almost given up on Kodak, they came out with a new professional slide film called Lumiere. I field tested some recently and it's an excellent film, with great color rendition and not much visible grain. Though the film is rated at ISO 100, I found I got better image quality shooting it at ISO 80. This is an especially good film in low light situations and it accepts pushing well.

Before singing the praises of color slide film more, let me point out the down side of this medium. First, slide film is less forgiving than print film. With print film your exposure can be off by one or two stops and you can still produce an excellent print from your negative. Not so with slide film. If your shot was not pretty close to perfectly exposed, you're not going to get a salable image. Second, since there's no negative with slide film, all you have is one irreplaceable original. If a publisher loses or damages your transparency, it's gone forever.

One way that I deal with this problem is to make duplicates of my best images. They never turn out quite as good as the originals, but I like to send duplicates to editors as samples. If they want to use a particular image, I can send the original immediately on request. Using these duplicates also helps to keep my images from being tied up too long at one place. Some photographers take this one step further: They have reproduction-quality 70mm duplicates shot, so they never have to send out their originals. You may be able to find a lab that offers this service in your area. If not, several reputable mail-order labs produce 70mm duplicates.

Some magazines still buy black-and-white prints, but they rarely pay as much for them as they do for color images. For many years I always took along an extra camera body loaded with black-and-white film so that I could shoot both in black and white and in color, thinking that this would give an editor more choice when laying out an article. But I'm not sure it got me any extra sales, and today I rarely shoot anything but color slide film. Editors can always have a black-and-white conversion made of a slide if they don't want to run the image in color.

2

BLINDS AND OTHER CAMOUFLAGE

ONE OF THE GREATEST problems in photographing wild birds, especially the smaller species, is to produce a frame-filling image on your film. Inevitably, the first few rolls of film a would-be bird photographer shoots are far from satisfactory, with the birds looking microscopically small in the pictures. It's a frustrating experience. Allow me to suggest an easy solution: Move closer to your subject.

That's easy to say, but getting a timid songbird to sit still while you approach it may be quite a bit more difficult. It helps if you can hide your presence by camouflaging yourself to blend into a bird's environment. Then you can take close-up pictures without the bird's even being aware of your presence.

Before going any further, one basic question should be addressed: What *is* camouflage? When most people think of the term, visions of blotchy green, brown, and black paramilitary uniforms enter their minds. Actually, camouflage is a more relative term. What could be called camouflage in one kind of habitat might jump out from the background in another. Though dark green and brown camouflage clothes might blend in well with marsh and woodland habitats, they'll give you away immediately in a desert or a snow-covered mountain-

side. The point is to always pick clothing or blind material that blends in with the area where you're photographing. Don't just put on some generic camouflage clothing and expect to become invisible. I know it sounds simple, but I often see photographers wearing green camouflage outfits in areas where they're totally inappropriate, as though camouflage were a trademark of their profession. Myself, I'd rather be able to get closer to my subject.

If you take most of your pictures in one area, it's easy to choose materials and clothes that blend in. Most camouflage clothes come in either green or brown tones to fit particular habitats. You can also get white clothes for snow. Camouflage clothing is relatively inexpensive and it does help you to avoid being spotted by birds, especially if you stay still. You can buy camouflage clothes at most sporting goods stores, or go to a military surplus store and get some camouflage combat fatigues. They're a good buy if they match the background colors where you'll be using them. I'm a firm believer in doing things inexpensively whenever possible—as long as it doesn't compromise the quality of the finished product. Combat fatigues work great.

When people think of hiding themselves from wildlife, they always think of visual camouflage, but there's another level to this game that can be just as important—auditory camouflage. By that I mean that you must wear quiet clothes. Pants that whistle whenever you brush past foliage or make noise when you move are a dead giveaway, no matter how well their color blends in with the habitat. I've seen clothing made by reputable outdoor-equipment manufacturers that was ridiculously noisy, especially some of the modern miracle materials. These clothes obviously weren't designed with any kind of stalking or hunting in mind. In bird photography, silence is definitely golden.

The important thing about camouflage is how you use it. No matter how well your clothing blends in with your surroundings or how quiet you are, it won't do you any good if you're out in the open. Try backing up into some dense foliage. Sit down and stay perfectly still. Let your camouflage work for you.

Sunlight reflecting off your face can be a problem, particularly for Caucasians. Pale skin is highly reflective and stands out like a bright neon sign advertising your presence to passing birds. I've seen wildlife photographers rub dirt on their faces to minimize this problem (not the

most pleasant or sanitary thing to do), or apply camouflage makeup to their faces. I've never gone that far myself. It's messy and takes time to put on and take off. If face glow is a problem where I'm photographing, I use a camouflage head net. This hides my face, keeps mosquitoes away, and can be put on or taken off in a second.

A shiny tripod also sometimes frightens shy birds away. If you have a chrome-finished tripod, you may want to spray paint it a neutral color, such as flat gray, tan, or army green. (You should only do this when the legs are retracted; if you paint the entire tripod with its legs fully extended, you'll probably never be able to retract them again.) Or you could buy a roll of camouflage tape at a sporting goods store. It's designed for hunters to tape over their shotgun barrels, but it also helps to make tripods and lenses less conspicuous. Be sure to ask for the self-adhering kind that doesn't leave a gooey mess when you peel it off.

BLINDS

The most effective way to hide yourself from birds is to use a blind; it's the closest you'll ever get to being invisible. A blind should be a basic item of equipment in any bird photographer's arsenal. I've had birds come so close to my blind that my telephoto lens was not only unnecessary, but also unusable.

Plenty of ready-made blinds are advertised in photography magazines and specialty catalogs. I've field-tested a lot of them, but have yet to find one that is anywhere near ideal for my purposes. And they're expensive. What if it blows away in a wind when I'm not there? Or gets stolen or vandalized? The best blinds are ones that you can leave out in the field for days or weeks so local wildlife gets used to it. Who's going to do that with a $200 blind? Granted, ready-made blinds are very portable, but I've never seen one that set up as quickly and easily as the manufacturers claim or was as useful as it should be. Get something that you wouldn't cry over losing, and get out and use it.

If you opt to build your own blind, you can find camouflage material sold by the yard for a reasonable price at many sporting goods or hunting shops. I always carry a few yards of this material around in the back of my pickup truck, in case I need to put together an impromptu blind. You'd be surprised how well you can hide just by draping the ma-

terial over some bushes or shrubbery without even building any kind of structure at all. Or, you can pound a few 1 × 2s (three feet or more in length) into the ground, then attach the camouflage to them with a staple gun. Cut a slit for your lens to poke through and you're set. It's easy, effective, and cheap.

An even less expensive alternative to camouflage material is to build your blind out of burlap. Some people take apart old burlap potato sacks and sew them together to form the sides of their blind. But it's much easier if you can find a place that sells burlap by the yard. I've seen rolls of it for sale at lawn shops and farm supply stores. In many cases, the drab brown burlap works just as well as camouflage material to hide a photographer. And if you want to change its color, buy some fabric dye from the market and dye the burlap yourself in a washing machine.

If you're imaginative enough, you should be able to find even less expensive objects you can use for blinds. Many department stores are happy to give away the cardboard boxes used to pack washing machines, refrigerators, and other appliances. These are usually a perfect size for a blind, and some of them even have a wooden pallet on the bottom, which adds more structural rigidity. You just make a small hole in the front for your lens, cut a door at the back that you can tie shut, and you're all set: an instant blind. Would you like it to be more camouflaged? Get some cans of spray paint in several drab colors—olive green, brown, flat back—and paint wild blotches of color all over the outside.

I realize that no one's going to let you to set up a garish monstrosity like this in a nature preserve, but you probably wouldn't be allowed to erect the prettiest, most expensive custom-made blind there either. More bothersome to me, though, is the fact that a cardboard box is likely to turn to mush after a few days in a driving rain. But if you set it up in an undeveloped piece of property (in moderate weather), nothing's really much better than a blind made from an appliance box. It's free and ready to use, you can leave it set up for weeks in a field (if you have permission), and you won't be depressed if someone steals it. Cardboard box blinds have one other interesting possibility. If you cut off the bottom, it's easy to pick the box up from inside and move it to take pictures from a different angle, or to approach your subject more

BUILDING A TREE BLIND
IN ONE LARGE TREE

*Burlap held up by rope on
4 sides and top. Tacked down
at the bottom.*

2 × 6 boards

*3/4"
plywood
floor*

*A major crotch is
the strongest
place to build.*

*2 × 6 boards attached
securely to tree with
nails or rope*

TREE BLIND USING
4 SUPPORT TREES

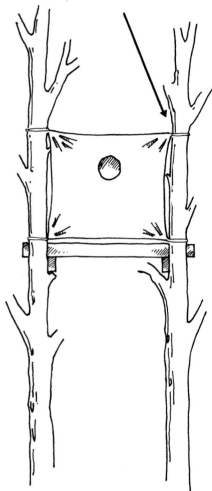

*Use ropes to attach burlap sides
and top to the blind.*

top view

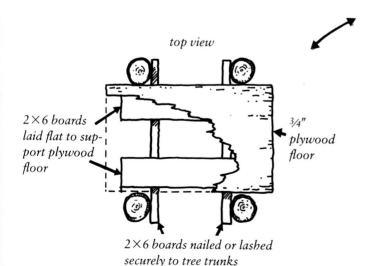

*2 × 6 boards
laid flat to sup-
port plywood
floor*

*3/4"
plywood
floor*

*2 × 6 boards nailed or lashed
securely to tree trunks*

*Tack the bottom edge of the
burlap to the floor of the blind.*

*Leave an open flap—one that
can be tied shut—for entering
or exiting the blind.*

*Climb up branches or use a rope
ladder to get into the blind.*

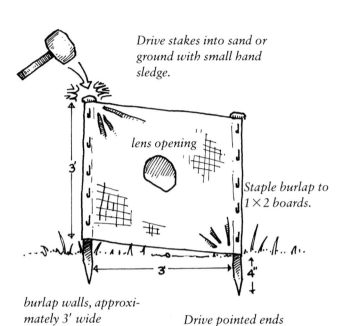

Drive stakes into sand or ground with small hand sledge.

lens opening

3'

Staple burlap to 1 × 2 boards.

burlap walls, approximately 3' wide

3'

4"

Drive pointed ends approximately 4" into ground.

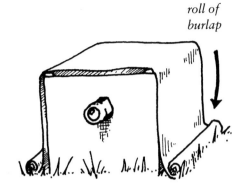

roll of burlap

You can roll extra burlap over the top after stepping inside. Top usually stays in place by itself, but you may want to attach it to the sides with clothespins in a wind.

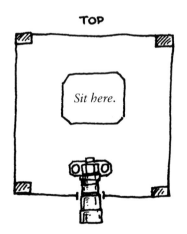

TOP

Sit here.

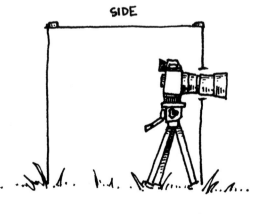

SIDE

Place camera on lowered tripod here.

closely. In fact, these appliance boxes are so useful, I'm surprised some enterprising photography-equipment manufacturer hasn't figured out a way to sell them to nature photographers.

Before setting up your blind, take time to study the area where you intend to photograph birds. Is there a particular location where birds are usually present at certain times of the day? If so, this would be a good place to put your blind. If any shrubbery or other natural cover is available, so much the better; you can set your blind in it. Your blind will blend in better with the habitat if it seems to be part of it. The ideal situation is to set up a semipermanent blind. Birds become remarkably used to a blind if it's left up in a field for a few days. You'll need to get permission from the landowner before setting up a semipermanent blind, but it's usually easier than you think.

Another kind of blind/camouflage setup you might like to try is the floating blind. This is great for photographing in marshes and estuaries, though I would caution people about using floating blinds in a large body of water or along the ocean; they can be dangerous. You can buy one of the ready-made innertube-type floats made for fishermen and convert it for photography. It's easy to build a canopy out of chicken wire that covers the entire inner tube and you. Then put camouflage material over the chicken wire (or better, weave reeds through it). Fishermen often wear flippers to move themselves around in deeper water. I prefer to use this setup only in shallow water. I like to have my feet or even my knees firmly planted on the bottom in order to hold my camera steady enough for good photography. I wear chest-waders to keep dry and comfortable.

You'll be amazed how close you can get to normally shy waterfowl and wading birds with a floating blind. If you move slowly and carefully, stopping whenever a bird gets nervous, it's almost like being invisible. But do be very careful.

At this point allow me to give some cautionary notes about blinds in general. One thing I can't stress enough is that you should make them comfortable. I used to pride myself on being able to stand a lot of physical discomfort. No more. Maybe I'm a little wiser... maybe just older, but now when I set up a blind, the first thing I think about is what it will be like to spend several hours straight in this tiny box. I also think about how I can make the box more comfortable.

*MAKING A FLOAT TUBE INTO A FLOATING
BLIND USING CHICKEN WIRE AND BULLRUSHES, ETC.*

How well I remember the days before I got smart. Once several years ago I set up a blind that measured three feet wide by six feet long by eight inches high—not even as big as a comfortable casket. I was photographing some nesting avocets at the time and I particularly wanted shots taken at bird's-eye level. I reasoned that I could lie flat on the ground with my camera balanced on a beanbag and get some nice pictures of the birds strutting past. In theory, it wasn't a bad idea, and I did get a few good shots, but my discomfort level was very high. Eight inches was way too low, even if I was lying on the ground—I was flattened out completely. I could barely breathe. And the sand beneath me was more wet than I had thought, since I hadn't foreseen to put down a ground cloth. In twenty minutes, my stomach was drenched, while my back was baking in the prairie sun. Changing film was almost impossible. And the heat . . . the sandflies . . . the smell . . . I can stand a lot of physical abuse, but if I can avoid it with a little effort, I will.

To accentuate the prehistoric-looking appearance of these cormorants, I laid down flat on the ground, shooting up at them, and waited for them to crane their necks at their approaching parent.

What should I have done to make myself more comfortable? I definitely should have set up a blind that was at least three feet tall, so I'd have had the option of sitting up and changing my position if I'd gotten stiff. I could have set up two cameras, one at ground level, another a couple of feet higher on a tripod. Then I could have shot from a couple of different angles, varying my body position as well as my photographs. I also should have put a waterproof ground cloth down to keep me and my equipment at least minimally removed from the

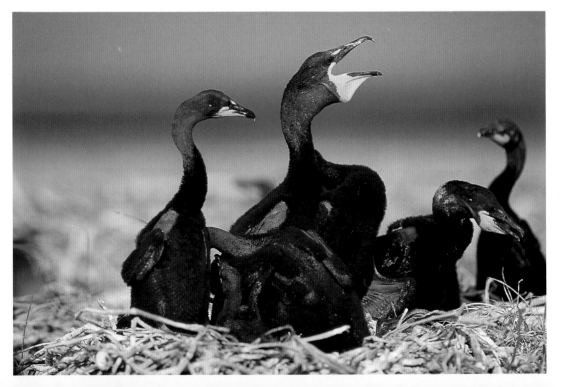

wetness and bird guano. I should have provided as many creature comforts as possible: a good supply of water or juice, a bag lunch, a towel to wipe the sweat from my brow.

I recall another time when I made a really stupid decision when I was building a blind. I had found some inexpensive camouflage material at a hunting supply shop's going-out-of-business sale. It was actually a huge tarp, but I thought I could cut it up and use it for the walls and top of a blind. I hammered it together and set it up on a small island where double-crested cormorants were nesting. Though cormorants are not particularly uncommon, I thought I could take some interesting pictures of these grotesque, prehistoric-looking young birds, reaching out toward their parents with black, snakelike necks.

Anyway, when picture-taking time arrived, I had a friend take me to the island in his canoe and drop me off. He was supposed to come back in three hours to see how I was doing. And how was I doing when he returned? I was practically dead. You see, this tarp was made of waterproof material. Talk about the greenhouse effect. As the sun rose higher in the sky, it became hotter and hotter in the blind. I thought it was funny at first. The eyepiece on my camera kept fogging up from the humidity inside. Great, I thought, I'm stuck out here gagging on rotten fish smell and I can't even take any pictures. Then it became frightening. It was like an oven in there. I was sweating profusely from every pore and I could hardly breathe the hot, damp, CO_2-rich air inside. I finally cut a small slit in the back of the blind with my pocket knife and sucked in the air outside with my mouth and nose. Eventually I had to cut the hole bigger and put my entire head outside the blind. I lay there gasping for a couple of hours till my friend came back.

I did learn a valuable lesson out there on that stinking island: Make sure you use the right blind material for the right situation. In a place where it was cold and rainy that tarp material might have been perfect, or I may have even wanted something heavier and more insulated. But in the blazing sun of that tiny island, I should have used a breathable material, such as burlap, that the breeze would blow through.

Whether you use a blind or you just wear camouflage to stalk birds, your chances for getting close-up shots will improve greatly. But you must have the patience to wait for the right moments. Patience is the greatest virtue and the supreme skill in any kind of wildlife photography.

3

STALKING BIRDS
EFFECTIVELY

STALKING IS A WORD that might seem easy to define. Most people associate stalking with being sneaky—moving furtively along in the shadows, trying to approach a wary quarry close enough to capture or kill it. Stalking with a camera does have the element of the hunt at times, of being so well hidden that you're almost invisible to your subject, even without a blind. But more often than not, a bird or animal does at some point in a stalk become aware of the presence of its pursuer. At that moment, if a photographer looks like a threat, the subject flees and a picture opportunity is lost.

Though stalking is, by definition, "to pursue quarry or prey stealthily," a deeper kind of stalking exists. Perhaps stalking is the wrong word—what I'm talking about is more a way of learning to blend into the background as a harmless, nonthreatening object. It's both a mental and a physical attitude—a way of breathing, looking, and moving that animals are comfortable with. We've all known people who have a natural affinity with horses, dogs, cats, and other animals. If you can perfect that quality—the ability to make animals feel at ease in your presence—getting close to birds is easy.

I've been trying for most of my life to develop this kind of non-

threatening presence with wildlife. During my early teens I took up falconry, an activity that requires the same qualities as those needed for bird stalking— infinite patience and the ability to move slowly and deliberately around a wild bird. Above all, falconry taught me not to stare. Hawks and most other kinds of wildlife are terrified by a fixed gaze, because in nature predators stare at their quarry just before they attack. I learned to look at my birds obliquely, taking brief glances with my peripheral vision when I was close to them. Eventually, I didn't even have to do that. My relationship with the hawks became more and more instinctive.

I try to achieve that same kind of rapport with the wild birds I photograph, whether I'm stalking them in the open or hiding in a blind. (Even while you're hidden in a blind, I'm convinced that the birds you photograph are aware of your presence at some level; they just don't recognize the shape of a blind as a threat.)

If moving slowly and gracefully is not your forte, it's possible to take excellent pictures of birds without ever learning to stalk. You'd just be more dependent on using blinds to hide yourself. But stalking is a fascinating method for getting close to birds, and by learning how to do it well, you'll be a better all-around bird photographer. You'll certainly be able to stay quieter and sit more still for long periods, which will help even if you do use a blind.

In situations where, for various reasons, it's impossible to get close enough to my subject by stalking, I always use a blind, because I prefer to work at the closest possible distances my telephoto lenses will allow. The minimum close focus of my 400mm lens is about twelve feet, and that's invariably the distance I try to shoot from. With my 300mm I get even closer. I try to work without a blind as much as possible because of the added mobility that stalking affords me. You may be amazed to think that someone could get close enough to take frame-filling pictures of a wild bird without hiding inside a blind, but I can assure you that it's possible. If you dress in drab clothing, move slowly, and spend hours in sometimes uncomfortable positions, many birds will come to accept your presence among them.

A lot of my stalking experience has been with shorebirds wintering along the coast of Southern California. Shorebirds are irresistible to me. No matter what species, and regardless of whether they're alone or

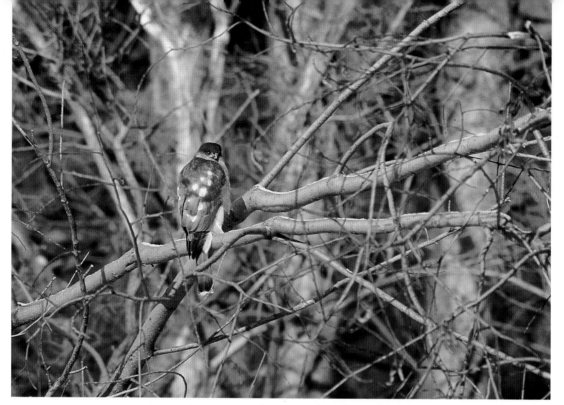

This sharp-shinned hawk (above) let me get closer than I expected, but I like the distant shot (above) just as much or even more than the close-up (opposite page).

When stalking a bird with a camera, stop periodically and take a few shots. If the bird flies off before you get as close as you'd like, at least you'll have some pictures.

in massive groups, they make excellent photographic subjects. The reason why is a little anthropomorphic—shorebirds have personality. Running back and forth with the waves, rummaging through seaside debris searching for food, or even just sitting in a group asleep with their heads tucked in and a leg pulled up, shorebirds are fascinating.

My favorite tactic for photographing shorebirds is to go out just before dawn in winter to a shorebird staging area, where the birds gather to fatten up before continuing on their long migrations. When I travel to the West Coast, I almost always visit my special shorebird spot—a tiny sand spit protruding into a bay near where I used to live. Though the birds there are more suspicious than the shorebirds at public beaches, the variety of species and the numbers are better. I always take as much time as necessary and stalk carefully in order to get close enough to take the kind of pictures I'm after.

A typical stalk there usually goes something like this: It is almost light outside, but a damp, heavy mist makes visibility poor. You see the outline of hundreds of shorebirds along the sand spit. A frosty chill makes you shudder deeply, but you do your best to keep still. Nothing you can do, though, masks the steam from your breath as you exhale.

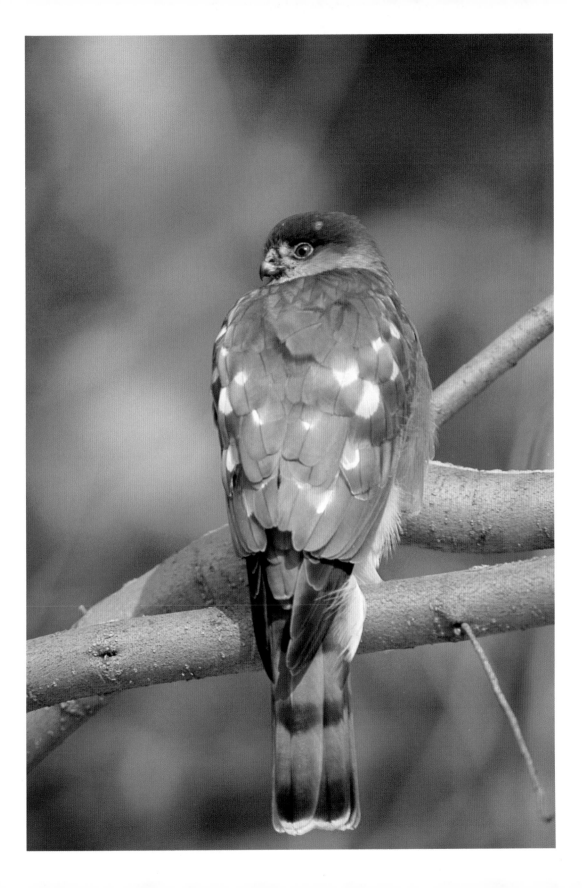

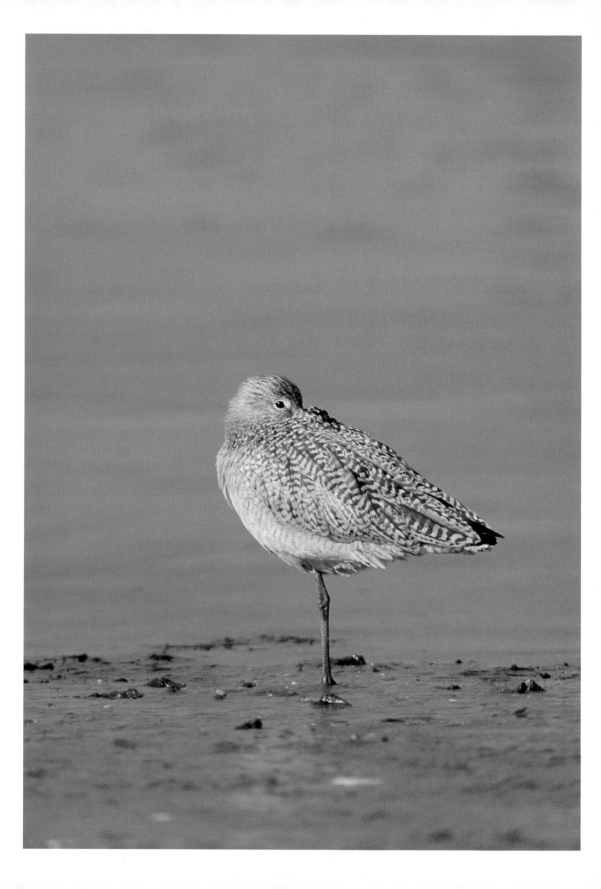

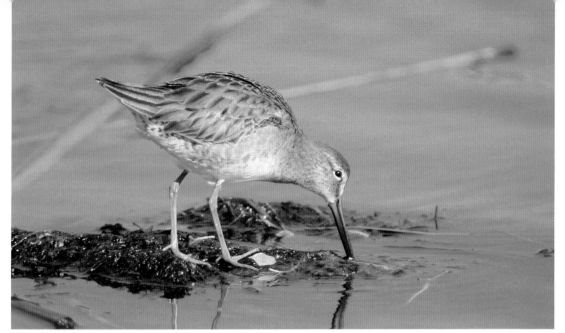

Shorebirds are among the most photogenic birds. Left, a marbled godwit balances on one leg with its head tucked in for a short nap.

Above, a dowitcher bends down in its characteristic feeding pose on a mudflat.

Lying down with your camera and telephoto lens thrust out before you on top of a beanbag, you move forward, less than six inches at a time. You push your camera ahead first, then drag your body along to catch up. You approach the birds slowly, watching them with your peripheral vision, rather than staring at them directly.

Most of the birds are still asleep, with heads tucked deeply into their back feathers. Occasionally, one lifts its head, gazes at you for an instant through half-closed eyes, then tucks its head back into place. They are a widely mixed group—dunlins, sanderlings, a few godwits. You notice a couple of ruddy turnstones are already awake, searching for food at the water's edge.

As you move to within thirty feet of the flock, you sense uneasiness in a few birds. You know that if just a couple of birds panic, the entire flock will explode. Slowly, you sit down on the sand and wait. Five minutes . . . ten minutes . . . fifteen minutes . . . the birds settle down. You begin sliding slowly, almost imperceptibly closer without getting up.

You stop occasionally to look through the camera. Framing the closest birds, you experiment with composition. You've got plenty of time. Your camera's exposure meter tells you there's nowhere near enough

light for photography, but you are excellently placed, less than fifteen feet from the flock. You know that soon the sun will start gradually burning off the morning mist. And for a brief space of time, the light will be perfect—bright enough to saturate the film with the subtle colors of the shorebirds, but wonderfully diffused by the rapidly vanishing mist.

This is a fascinating experience for anyone who likes to watch birds. As you sit there for perhaps two, three, or more hours, you have nothing to do but wait patiently. You are totally focused on the moment. It becomes an exercise in total concentration, almost a meditation. You find that you are hyper-aware of the colors, textures, and shapes of the natural scene. You become part of the environment. It's a remarkable feeling.

As the morning slowly warms up and the light grows stronger, you raise your camera and click off a few shots. You feel giddy with excitement. Here you are, within a few feet of a massive flock of shorebirds, and they seem to regard you as easily as an old post or a rocky outcropping among them. In your mind's eye you can already see the photographs and they're great: a long-billed curlew looking comically large among some Lilliputian dowitchers, a couple of redknots having a shoving match, a maverick dunlin taking an icy splash-bath in the middle of some sleeping sandpipers.

If you're a good stalker, shorebird photography can be that interesting and enjoyable. On more than one occasion I've had the experience of having a flock of shorebirds return and land all around me after being flushed by a passing jogger or cyclist. You know that you've been completely accepted when that happens.

Another effective stalking technique is to sit down in a good location and wait for a bird to approach close enough for you to take a picture. Some people may not consider this to be true stalking because you're not actively trying to sneak up on a bird, but I disagree. Being able to remain motionless for long periods and to blend into the habitat is the essence of stalking, and the better you are at this skill, the more effective you'll be as a bird photographer.

Besides being able to stay still, to be good at the "sit and wait" technique you must be good at choosing the best place to set up your camera, or you might spend a lot of long, boring hours waiting in vain for

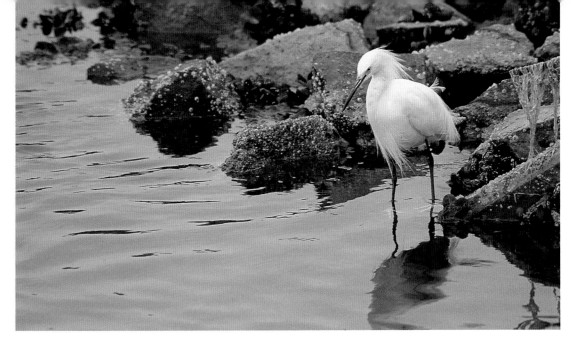

Sometimes the birds will come to you. This snowy egret was foraging in an estuary. I sat quietly and within a half hour, the bird moved within a few feet of me. It was so intent on catching fish that I don't think it noticed I was there.

some birds to show up. It helps if you know the habitat well and the behavior of the birds that inhabit it. If you spend a lot of time watching a local marsh, you may notice that some of the wading birds or waterfowl frequent certain areas at particular times of the day, to feed, bathe, or perhaps sun themselves and preen. Get your chest-waders on, move over to an area like that, and try to push yourself back into the reeds to hide yourself. If you have patience and can take sitting for a long time in muck and water, some birds should eventually come close to you.

In some situations, you don't even need to hide yourself at all, provided that you know how to do a good imitation of a statue. I sometimes just walk out into the middle of a shallow marsh and sit down in the water, planting my tripod legs right down into the mud. Again, let me emphasize that this should be a very shallow marsh or the water will come flooding into your waders when you sit down. I've used this technique several times in the saltwater marshes and estuaries of the California coast to photograph black-necked stilts, avocets, and other interesting birds I found there. Getting set up was always easy. I just quietly waded over to the edge of the water and sat down. Of course,

some of the birds would walk quickly away or perhaps fly a hundred feet or so, but they would almost invariably start working their way back to where I was sitting, especially if it was a favorite foraging area. It was just a matter of waiting quietly for an hour or so.

I recall trying this technique once on the coast of Texas. I was there on assignment to gather information and take pictures for an article I was writing about the peregrine falcon migration. One morning I decided to take a few hours off and try to get some shots of some local wading birds. The place I chose to set up was little more than a huge rain puddle next to a construction site. Several tri-colored herons, white ibises, and one reddish egret foraged in the muddy water. Not far away, bulldozers noisily ripped the topsoil and plants away, destroying the habitat to make way for another high-rise hotel complex. I didn't take the time to stalk carefully. I figured that the birds had been around a lot of construction workers and were probably somewhat used to people. I walked quickly out to an area where a lot of the birds were feeding, and I sat down. The birds, meanwhile, had flown to the other side of the water, next to some reeds.

Though I was pretty sure that the birds would come back fairly quickly, I was surprised at what a short time it took. Within twenty minutes they were all around me, some of them actually getting too close for my 400mm lens. One tri-colored heron was so engrossed in foraging that it came within six feet of me. I was debating for a moment whether I should try to switch to my 80–200mm zoom lens, but a couple more birds came near that were a better distance away. As the Gulf sun warmed the midmorning air and cast a pleasant rosy glow over my tiny piece of wetland, I shot roll after roll of film of these cooperative wading birds.

When you go to a new place like that, you really never know exactly how the birds are going to act. You may find that they're as tame as the wading birds along Florida's Anhinga Trail, basically willing to pose for anyone who passes by. Or they could be afraid of their own shadows. The more you practice and the more places you visit, the more instinctive you'll become at sizing up a situation quickly and using the most effective stalking technique.

Some photographers like to work a marsh more actively than this. They put on their waders and walk through chest-high water, pushing

Tall and graceful, herons are a joy to photograph. I sat in a shallow puddle next to a construction site photographing this tri-colored heron (opposite page) as it strode boldly past.

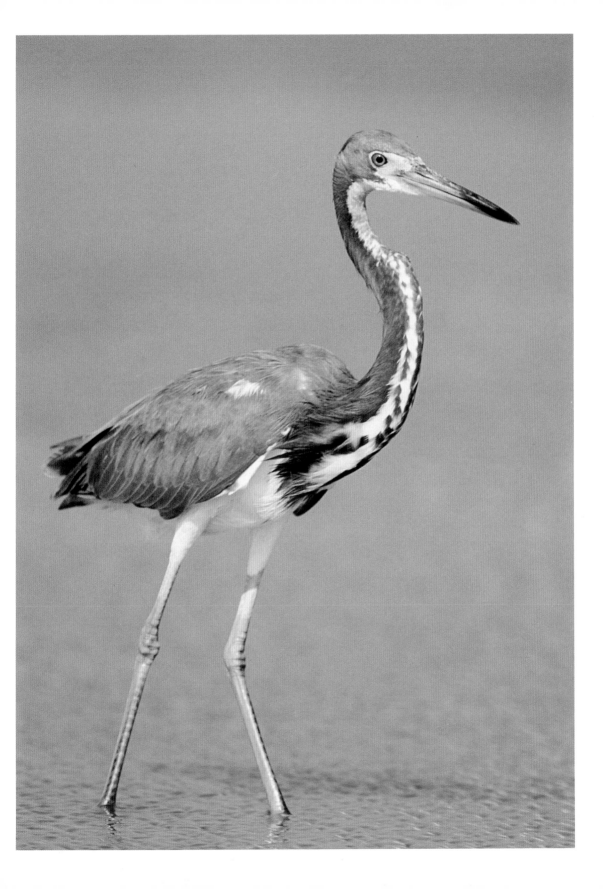

their way through the reeds. I've done this myself and have taken a few decent shots, but more often I end up with pictures of grebes or other marsh birds peeking furtively through the reeds at me, their bodies mostly blocked by vegetation. Rather than do this anymore, I rely on a floating blind when working in water that's more than thigh deep, staying in the open water and photographing birds along the edge of the reeds.

Another good way to stalk birds in a watery area is to use a canoe. Many birds don't seem to recognize a canoe or small boat as a significant threat. I remember the first time I tried canoe photography was several years ago in Morro Bay, California. I paddled a rental canoe out into the vast tidal water of the bay and approached swarms of shorebirds on a sandbar. These normally shy birds were virtually fearless. (It was not all smooth sailing on that trip, though; I almost got left high and dry when the tide rushed out.)

These days I often use a canoe to get out to a blind or to an area that's inaccessible by land. En route, I always keep my camera ready in case an interesting picture opportunity comes along. Perhaps a western grebe will pop out of some aquatic cover nearby. If something does show up, I try to lie down very still and prop my camera on a beanbag on the edge of the canoe. It doesn't always work, but sometimes you get lucky. The main problem with canoe photography is that it's hard to hold your camera steady when the canoe is rocking in the water. For that reason, you'll need to use a fast shutter speed—at least 1/1,000th of second with a 400mm lens. You'll probably need to use a fast film to get a correct exposure. I recommend Fujichrome 100 pushed one stop in processing (which provides an effective ISO of 200).

You can also use other kinds of vehicles for stalking birds. Cars are especially good. If I'm driving through a good area, I always have my camera, telephoto lens, and beanbag ready on the seat next to me. If I see a bird up ahead, I can roll down my window, turn off the engine, and coast quietly up next to it. With the beanbag draped over the lowered window, I can hold the camera fairly steady and fire away.

I have a friend who sometimes uses a bicycle to photograph birds. He rides along a coastal bike path with a camera and telephoto lens slung across his shoulder, bandolero style. When he sees something to photograph, he crouches down behind the bike and rests the camera on

his padded handlebars. This seems incredibly awkward to me, but he has gotten some nice shots of killdeers, various terns, and waterfowl this way. Anything's possible if you use your imagination.

The strangest thing I ever used for stalking a bird was an all-terrain vehicle (ATV)—one of those four-wheeled quasi-motorcycles you often see tearing across the wide-open spaces. I was driving along the beach on the coast of Texas during the peregrine falcon migration, hoping to find one of these remarkable birds to photograph. I finally spotted one sitting on the side of a sand dune, plucking a freshly caught blue-winged teal. How could I approach the bird without spooking it? One thing in my favor was that the bird was an Arctic peregrine; these birds come all the way from Alaska, northern Canada, and Greenland each fall, stopping along the coast of Texas to fatten up before continuing to South America. Many of the first-year birds, like this one, have had few encounters with humans. Some of them are remarkably unsuspicious.

I thought about the situation for a couple of minutes, then decided to try approaching the bird with the ATV. There was a luggage rack on the front, with my pack lashed to it. I put my camera with a 400mm lens on top of the pack, held in place with a bungee cord. Bending down forward over the handlebars, I moved slowly forward on the ATV, stopping whenever the bird stopped plucking feathers from the duck. Each time I'd gotten as close as I thought I could get, I turned off the engine and snapped a few pictures. Then I'd fire up the ATV again and try to get closer. The ATV was so noisy, I figured I'd have no chance to get really close. I was wrong. The last shots I took were full frame, and then I moved away without ever flushing the bird.

I was so surprised by this peregrine's behavior that I went back later in the day to make sure that the bird hadn't been sick. All I found was a few pieces of duck carcass and feathers. The falcon had gorged and flown away. I guess she wasn't about to let a photographer and a noisy ATV spoil her duck dinner.

I think this is what I like about stalking birds with a camera: having a close encounter with another life form. For a short time I became part of that falcon's life. Although the moment has ended, I still have the pictures to remind me.

4

BIRDS IN FLIGHT

FOR ME, THE MOST fascinating thing about birds is their ability to fly. It doesn't matter whether it's the hyperkinetic, insectlike flight of the hummingbird; the effortless long-distance gliding of the albatross; or the awesome power dive of a falcon—I can watch any of them for hours. I'm not the first to feel that way. The birds' mastery of the air, more than any other quality they possess, has enthralled humans throughout the centuries.

Flying birds have also caught the interest of many photographers. Unfortunately, photographing birds in flight is often frustrating. The shots rarely turn out as good as they look in your viewfinder. Invariably, most of the images will be either too small, too dark, too light, too blurred from motion, or out of focus. Sometimes you even miss the bird entirely. It happens . . . a lot.

So what is it that keeps bird photographers going, running roll after roll of film through their cameras trying for good flight shots? I can only answer for myself: When it all comes together, I end up with some wonderful, one-of-a-kind shots. But if you're tempted to try flight photography, be forewarned: You *will* burn up a lot of film. That's the nature of the game. One keeper for every ten flight shots you attempt is a pretty good success ratio.

If you use a motordrive, a virtual necessity for flight photography, I advise you to set it on single-frame firing. The continuous-firing mode

will eat up a 36-exposure roll of film in a matter of seconds, which can be expensive if you spend a full day in the field taking flight shots. It's better to practice and polish your technique before shooting that much film.

Choosing the right lens is important. To take frame-filling pictures of birds in flight, you'll definitely need a good telephoto lens in the 300mm to 400mm range. Though for photographing bird flocks flying past or groups of ducks rising from a pond, a less powerful lens can be adequate, I always bring a long lens with me. Internal-focus lenses are best, because they focus quickly and smoothly, with fewer turns of the focusing collar required in order to go from minimum close focus to infinity.

Photographing a moving object with a telephoto lens takes a lot of skill. These lenses magnify a bird's image wonderfully, but they also magnify the slightest movement of the camera. In addition, the depth of field (area in sharp focus) is relatively narrow with a long lens, so accurate focusing is critical. You not only have to spot and follow a fast-flying bird in your viewfinder, but you must also hold the camera rock-steady, bring it into sharp focus, and press the shutter release at the perfect instant. It makes juggling bowling balls seem like child's play.

A ferruginous hawk streaks across a late-afternoon prairie sky. With flight shots, try to have plenty of space in front of the bird or it will look like the bird has nowhere to go.

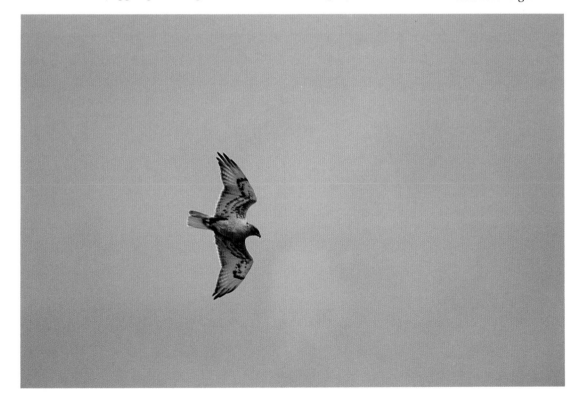

The most widely used technique for photographing moving objects is called panning. Simply put, you point your lens at an incoming object and follow it as it goes past, swinging the camera smoothly in a horizontal arc. You've no doubt seen photographs of racehorses, runners, or cars speeding past with the background blurred behind them. These photographs were all taken by panning.

You can pan by hand-holding a camera, by mounting your camera on a rifle-stock-style shoulder mount, or by using a tripod. Shoulder mounts are popular with many photographers. I've tried several and I really like the German model sold by Lepp and Associates. It has a threaded hole in the bottom that I often screw a monopod into to increase my stability. I plant the monopod on the ground and pivot with it, using the shoulder mount to steady my swing. I sometimes also just pick the whole thing off the ground as I swing. The weight and heft of the monopod seems to dampen camera shake somewhat. But a tripod is infinitely steadier than a shoulder mount/monopod combination. It's perfect for photographing large, slow-flying birds—pelicans, herons, eagles—that tend to keep to a predictably straight course in flight.

I've used a fluid-head tripod with a panning arm and also a tripod with a ball-joint head for panning. Though the panning arm was use-

A lumbering flyer like the American white pelican is easy to photograph in flight: pan along with the bird in a smooth arc, focusing and snapping pictures as it goes past.

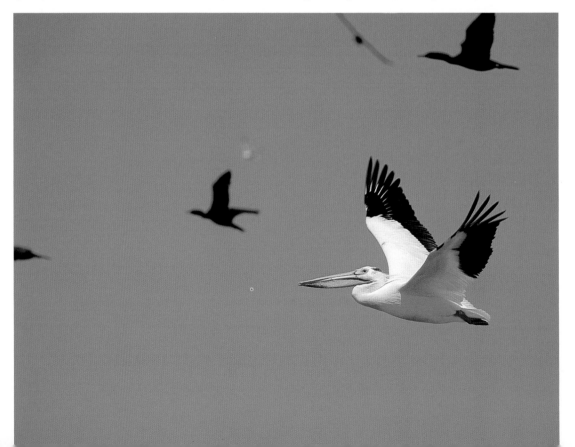

ful for some flight shots, a ball-joint head is much more versatile for all-around bird photography. I recommend just buying a tripod with a good ball-joint head and learning to pan smoothly with it.

I sometimes set up a camera on a tripod next to a coastal channel where brown pelicans fly by or dive after unsuspecting fish. As a bird approaches, I set the vertical adjustment on the tripod head up or down to match the anticipated level of the bird's flight path (this takes a little practice but is not difficult to master). I start focusing as soon as possible and try to keep the bird in sharp focus as I swing through with the camera. I usually fire off two or three frames as the bird is approaching, and another when the bird is alongside. I sometimes experiment with slow shutter speeds on these large, lumbering flyers. Using a tripod and panning along with the bird as it flies past creates a nice effect—a sharp image of the pelican's head and body, with blurred wings and background to accentuate speed. It's fun to see just how slow a shutter speed you can use effectively. I sometimes shoot at 1/60th of a second or even less using a 400mm lens. But to do that, you must be able to pan smoothly.

If you've ever seen a skeet-shooting competition, the technique is similar. The shooter lifts the shotgun, swings it onto the clay target as it flies through the air, fires, and then follows through with the swing as the target turns to powder. The smoothness, breath control, and hand–eye coordination required in flight photography are all there. But fortunately for the shooter, you don't have to focus a shotgun.

Birds that twist, turn, and dart in the air are hard to photograph using a tripod, but it takes incredible steadiness and coordination to take hand-held or shoulder-mount flight shots. I advise practicing for a while without any film in your camera. Start by sitting in your front yard trying to pan along with cars as they drive past. Then move on to more challenging subjects—a thrown football or Frisbee. You might at this point start actually taking pictures of moving objects so that you can evaluate your progress. Go to the horse races or to a track meet and photograph the competitors as they speed past. Eventually try some easy bird subjects, such as pigeons and gulls. Be sure to practice focusing as well as panning. You must do both simultaneously, and also press the shutter release.

Focusing quickly and accurately on a fast-moving object is incredi-

bly difficult. It takes speed, a good eye, and, above all, lots of practice. Wildlife photographers generally employ two methods: prefocusing and follow-focusing. In the first method, the camera is focused on a place where you expect a bird to pass by closely. As the bird approaches, you follow it in your viewfinder until it reaches the point of perfect focus, and then trip the shutter. This works especially well if you're in a blind near a nest or a favorite perching area of a particular bird. You know the bird will have to fly past to get there and if you're prepared, you can get a nice image.

Another example of prefocusing is to focus on a bird that is perched, then snap the shutter as it takes off. Usually a bird will still be in sharp focus for an instant—especially if it flies off in a lateral direction. I had excellent results using this technique to photograph prairie raptors in Canada. Whenever I spotted a hawk on a fencepost as I was driving down the road, I rolled my window down, turned off the engine, and rolled to a stop. Usually I just had time to focus the camera before the bird took off. I've taken some of my favorite flight shots that way.

With the follow-focus technique, you follow a flying bird in your viewfinder, adjusting the focus as you go, attempting to maintain a consistently sharp image. It takes a little getting used to, but it's definitely the way to go once you've mastered it, because you are constantly ready to snap a picture when you see a pleasing image in your viewfinder.

Another option is to buy autofocus equipment. Though many photographers, particularly in the wildlife field, have resisted this technology, autofocus is improving all the time and it's definitely here to stay. I'm not absolutely sold on autofocus yet for flight photography. Though I've taken some excellent shots with autofocus lenses, the questions remains: Could I have taken the same pictures as easily, and perhaps even more easily, with manual equipment? In many cases, the answer would have to be yes. The major problem with the system I've used—Nikon— is that the focus sight in the center of the frame has to be kept on the subject to keep the image sharp. Sometimes when the sight slips off the bird, the lens instantly focuses to infinity, turning the bird into an indistinct blur that gets lost in the viewfinder. That never happens to me in manual focusing. But autofocus has been great for taking quick grab-shots of, for example, shorebirds running past at the beach.

A motion-blurred image is another common problem with pho-

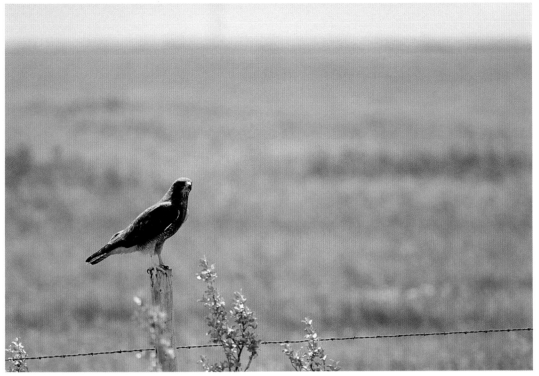

One way to get decent flight shots is to focus on a perched bird and snap a picture as it takes off. Driving across the western prairie, I spotted this Swainson's hawk perched on a fence post. I rolled down the passenger window, turned off the motor, and had my 400mm lens pointed at the bird by the time I rolled to a stop.

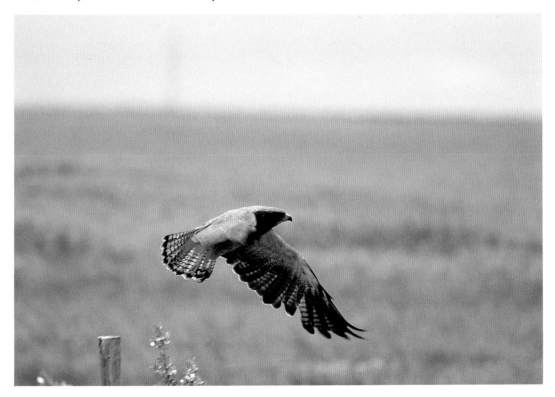

tographing birds in flight. One obvious remedy is to use a fast shutter speed. A shutter speed of 1/1,000 of a second will eliminate most camera-movement problems, even if you're using a 400mm lens. In most situations, however, you'll need a relatively fast film to get a good exposure at 1/1,000 of a second. My favorite film for the job is Fujichrome 100. For flight photography, I usually set my camera for ISO 200 film, shoot the entire roll, then have the film pushed one stop during processing, as I described in the section on film in Chapter 1.

Determining the right exposure setting can be a problem in flight photography. The built-in exposure meters in most cameras are fine for average lighting conditions, but when you have a dark bird flying across a brightly lit sky, you might have problems. The light intensity of the sky often overpowers your camera's built-in exposure meter in this situation and you end up with a black silhouette of the bird on a perfectly exposed sky (which is all right if that's the image you're after). This is a problem with many automatic-exposure cameras. To compensate, take a meter reading of something with a color and reflective quality similar to those of the bird you want to photograph—the ground, a rock, some shrubbery—and set the shutter and aperture manually. For example, once while I was photographing prairie falcons flying near their nest cliff in the Mojave Desert, I took a meter reading from a pale sandstone cliff colored very much like the underside of the birds. My transparencies came out perfectly exposed.

For those of you who have cameras with matrix metering systems, this manual overriding of the automatic-exposure system is unnecessary. Such systems take into account the lighting requirements of foreground subjects and balance the light accordingly. I now use a Nikon F4S camera and I'm amazed how accurately its exposure system assesses difficult lighting situations.

One thing that makes flight photography infinitely easier is choosing an ideal place to do your picture taking. Several places and situations I've encountered come immediately to mind—places where I practically just had to aim and shoot to get good pictures. I remember photographing terns several times at a manmade spillway where ocean water rushed into an estuary at high tide. Terns by the dozen hung in the air, hovering and swooping down on the tiny fish swimming through. I lay on my back, pointing my camera up at the birds as they

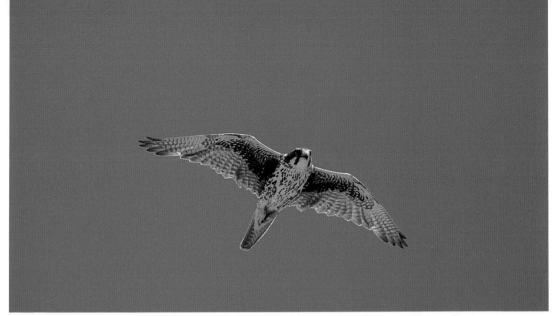

For an accurate exposure reading when photographing this prairie falcon in flight, I took a light-meter reading from a nearby sandstone cliff similar in color and light reflection to the underside of the bird. I then set the aperture and shutter speed manually. Had I taken a light-meter reading of the bird against the bright sky, it might have yielded a silhouette of the falcon instead of this perfectly exposed image.

hung in place on a light breeze barely twelve feet from me. If you look around your area you may find a similar place that attracts terns, kingfishers, and other interesting birds.

In the summer you can sometimes get good flight shots of birds near their nesting territories. Many species are aggressive toward intruders, whether bird, animal, or human. I don't encourage unduly bothering nesting birds—the welfare of the nesting pair should be your primary concern; no photograph is worth the loss of a bird's eggs or young. But sometimes you can take excellent flight pictures of parent birds without even getting close to their nests.

I recently photographed an adult avocet in flight at a local sanctuary without ever leaving the nature trail. One of the birds would invariably fly over to investigate whenever a hiker walked past. It didn't seem overly disturbed. In fact, the bird never let out a distress call. I sat down there and was ready for the bird whenever someone came along. It was a perfect opportunity for photography.

Aside from the physical and mental skills you must polish to become proficient at flight photography, you can also employ some tactics to improve your success ratio. One of them is to look for the moments in

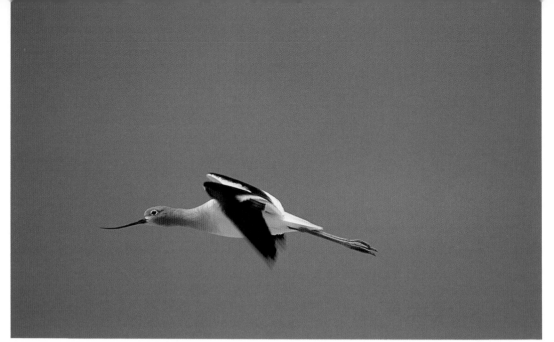

This picture of an American avocet is one of my favorites. I panned along with the bird as it flew past, using Fujichrome 100 film pushed one stop in processing so that I could use a fast shutter speed.

bird flight that have the least movement. For example, it's easier to get a sharp flight shot of a pelican when it stops flapping its wings and begins to glide. The instant a falcon runs out of momentum after pulling out of a dive, there's a slight pause before it turns over and dives again. When a duck is backpaddling to land on water, its body is moving very slowly. Though the wings will be a blur, if the duck's body is sharp, you could get a great picture. When a tern hovers over a fish-filled channel, or a gull hangs in the air above you, suspended by an ocean breeze, or a migrating hawk glides past you on fixed wings—these are the moments to watch for. Take advantage of them whenever you have the chance.

Flight photography can be a lot of trouble and it does burn up a lot of film, but it will all seem worth it the first time you present a slide show of your flight shots. Nothing impresses people more than a bright, clear image of a bird in flight.

5

NEST PHOTOGRAPHY

O F ALL THE SEASONS of the year, my favorite is spring—a brief interval when the land reawakens from the dormancy of winter. A profusion of new life blossoms all around: flowers, trees, wildlife. But nothing heralds the arrival of spring more effectively than the birds. Each morning at dawn their songs fill the air as they stake out their territories and nest sites.

Springtime is full of possibilities for a bird photographer. Many bird species are almost impossible to photograph at any other time of year, but in spring their entire focus is on procreating their kind. They sit on prominent perches, loudly proclaiming their presence to the world. They spend long periods at their nests, caring for their eggs or young. It's never more easy to take close-up pictures of birds than when they're nesting. On the downside, however, it's also never more easy to cause them harm. If you bother nesting birds too much, they may abandon their nests. Or your presence may attract nest-robbing predators. You must be extremely careful if you're going to photograph nesting birds. No picture is worth the loss of a nest.

One way to get excellent pictures of songbirds without actually bothering the nest is to photograph singing males. Each male songbird stakes out four or five prominent perches from which they sing to announce their presence to potential rivals. If you take the time to watch

Sometimes the birds you're photographing help with composition. Here, the nestling on the left is looking at the nestling in the middle, which is looking at the nestling on the right, which is looking at the camera. A viewer's eye tends to follow the line of the bird's sight from one to the other, adding to the effect of the picture.

**WILD BIRD
PHOTOGRAPHY**

▲▾▲▾▲

56

a pair as they're setting up territories, you'll get an idea of which perches the male prefers to sing from. Then you just set up your equipment and aim at the perch that's best from a photographic standpoint. The bird will eventually return to that spot and start singing. That's the cue for you to snap away with your camera. Some of the finest pictures of singing songbirds were taken in this way.

This method doesn't work well in every situation. Deep-forest nesting birds, such as tanagers and many warblers, may be singing from perches above the forest canopy. Getting your camera gear up there to capture that can be difficult. But for grassland birds—bobolinks, meadowlarks, and many sparrows—there's no better way than this to photograph them. On the vast prairies of western Canada and the Dakotas, I've often lain flat on the ground, covered only with a tarp, waiting for a sparrow to return to a bush and start singing. Occasionally I've sometimes have had to wait for an hour or so for something to happen, but rarely longer than that.

Some photographers speed the process by using tape-recorded birdsongs to lure birds in quickly. Most birds are quite territorial—they stake out a claim to a prime piece of habitat and defend it aggressively against intruders. A bird sings in its territory primarily to warn other birds not to enter its domain. If another bird does enter an occupied territory and starts singing, these actions represent a direct challenge

to the resident male. This is exactly why birdsong tapes work so well. To avoid causing undue stress to breeding birds, use recordings sparingly—not more than a couple of times at one site in a season. You should be able to get all the photographs you need in that time, particularly if you only call the birds in when the lighting conditions are perfect. Remember, the welfare of your subject should be your primary concern when you're involved in any kind of wildlife photography. Birds are at their most vulnerable during the breeding season.

To lure in a bird with a playback, you'll first need to buy a cassette or compact disk recording of the species you hope to photograph. Many audio field guides are available that incude songs and calls of many of the bird species found in North America. I've listed several excellent recordings in Chapter 9 and in the Appendix of the book. Almost any decent playback unit will do, as long as it has a plug for an auxiliary speaker. You'll need a speaker and about twenty-five feet of cable (both available from Radio Shack) to complete your setup. Place your auxiliary speaker underneath one of the bird's singing perches, walk back ten or fifteen feet, unwinding cable as you go, then set up your blind, with your tape player inside.

Unless you set up your camera beside a nest and trigger it remotely from some distance away, taking pictures of parent birds at the nest always involves using a blind. Most photographers set up a blind slowly at a nest, adding a piece or two each day until it's finished. This is not a bad way to go if you've got the time. The birds are very used to the blind by the time it's ready to be occupied. It's also a good idea to bring a friend when you go to your blind. Birds haven't figured out how to count—if two people go into a blind, and one of them walks away, the birds think the coast is clear. I'm always amazed at how quickly birds return, and how calm they are if they've seen someone leave the blind. Once I tried stepping into a blind alone at a black-necked stilt nest. The birds never did settle down. They would return to the nest and even sit for a minute or two, but they eyed the blind suspiciously the entire time I was there. And every few minutes one of them would approach the blind and walk around it. I finally gave up. Now I always try to get someone to help me out. It's also a good idea to have the person come back at a set time to get you out of the blind. If you just burst out of the blind without warning, this too will make the birds suspicious of the

blind in the future. Birds may not know how to count, but they do have good memories.

Sometimes on a long trip it's just not practical to spend several days setting up your blind and allowing the birds to become slowly accustomed to it. In this case I take a more hit-and-run approach to my nest photography. As an example, I'll mention a white pelican colony I photographed during a long picture-taking excursion through the western states and Canada. I'd found the colony while canoeing around a small lake, looking for grebe and duck nests. I only had one day to spare, since my main goal on the trip was to take pictures of prairie raptors, and yet I had very few white pelican shots in my collection and no nest pictures of the species. What could I accomplish in one day of shooting? As it turned out, plenty.

First, I drove to the refuge headquarters and got permission to photograph the birds. Next, I went to a lumberyard in town and bought all the supplies I thought I'd need—several 1 × 2 boards, a small sledgehammer, a heavy-duty staple gun, a handsaw. I already had several yards of burlap to cover the simple structure I would build. I laid the pieces on the ground in a picnic area and began sawing on the boards.

Minimize the impact of photography on nesting birds. To take the pictures of American white pelicans on pages 58–61, I set up a makeshift blind in their colony and got all the shots I wanted in two hours. The birds were aware of my presence only during the few minutes it took to set up and take down my blind.

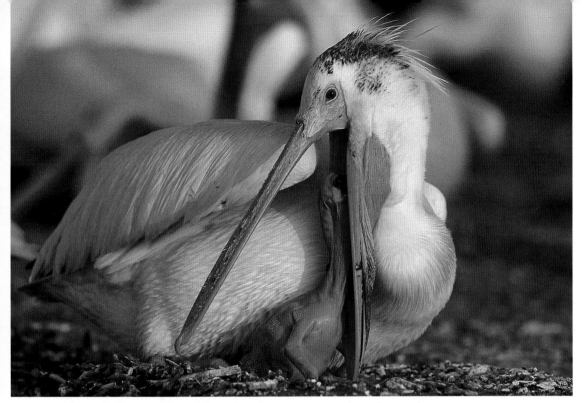

I cut four of them into equal four-foot-long pieces, each with one sharp end for driving into the ground. I hammered them into the ground about three feet apart and formed a square. I then cut the burlap to form walls and stapled it to the 1 × 2s. I now had the rudiments of a blind. I needed only to step inside, cut a slit for my telephoto lens, then drape the remaining burlap over the top as a roof. I used a few clothespins to attach the roof more securely. From the outside, it was not a bad looking blind. Inside, it was more than adequate.

Before trying it out on the birds, I decided to give the blind a dry run at another tiny island on the lake. The friend I was traveling with took me to the island. I jumped from the canoe, carrying the bundle of 1 × 2s and burlap, and ran ashore. Unrolling the bundle, I quickly hammered the four posts into the ground, giving each three or four whacks with the hammer. I stapled the burlap on, stepped inside with my camera and tripod, and pinned the roof on. When everything was set and I was comfortably sitting with my camera, I looked at my watch. The entire setup had taken only five minutes.

That afternoon at the pelican colony, erecting the blind went even more smoothly. The birds left their nests at the last possible instant,

and they returned as soon as my friend paddled away. I had arranged to photograph them for two hours as he looked for eared grebes nesting in some far-off reeds. The pelicans were oblivious to my blind. In the warm afternoon light, I snapped countless shots of the birds feeding their young. The pouches of the adults shone yellow-orange, in brilliant contrast to their stark-white plumages. I tried several lenses to vary my coverage as much as possible: group shots with a 50mm, tighter shots with an 80–200mm zoom, and closeup portraits with both 300mm and 400mm lenses. I'd almost worn a blister into the end of my shutter-release finger by the time I was through.

I was very happy by the time my friend picked me up. I knew I'd taken some great shots of the colony, and I also knew that my presence had made very little impact on the birds. I'd spent two hours with them, during which time I'm sure they were unaware of my presence. I'd only disturbed them for five minutes when I'd set up the blind, and less than five minutes when I'd taken it down. Taking numerous trips out to the island over a period of several days to set up a blind would have been infinitely more disturbing to the birds. The technique of setting up a blind quickly and photographing for a brief period may not

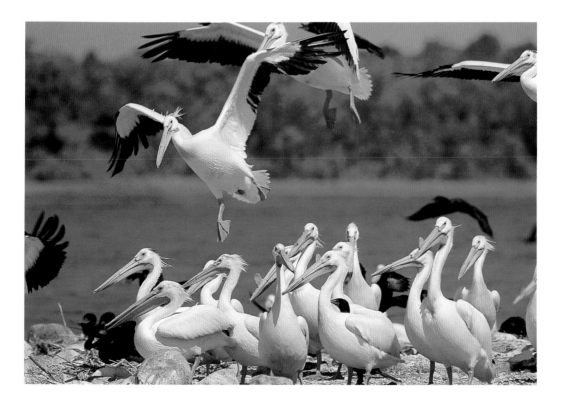

work on all bird species, but it does work with a lot of them. Besides pelicans, I've used it with avocets, stilts, phalaropes, grebes, ducks, and other birds that nest on or near the ground. If you have a situation in which you can use it, you should definitely give it a try.

For birds that nest high above the ground, building a safe, effective blind is more of a challenge. Many hawks, for example, build their nests near the tops of trees to give them a wide view of the surrounding country. I can think of three kinds of setups that work well for treetop nests. Number one, erect an elaborate tower adjacent to the nest and place a blind on top. Number two, build a blind in a nearby tree. And number three, attach your camera to a limb next to the nest and trip your shutter with a radio-controlled or infrared remote-triggering device.

A tower is something I've never used for photographing a bird's nest, though many of my friends have. It's definitely the most expensive way to go. You either have to buy ready-to-assemble scaffolding or design one yourself with lumber. It's a lot of trouble to assemble, and if it's not done right, a tower blind can be a death trap. I have a friend who's in his eighties now. In the late 1940s he set up a tower to photograph a heron rookery. During a windstorm, his blind blew off the top of his tower, almost taking him with it. Always be careful if you use a tower. It can be very dangerous.

I prefer the second kind of setup, though it's not the easiest. If you can climb a nearby tree and get even with the nest, then you don't ever need to climb the actual nest tree, which saves the parent birds some stress. In addition, you're not leaving a scent trail up to the nest for predators to follow. Raccoons in particular are always attracted by human scent and will devour eggs or young birds if they get a chance. It's not hard to build a fairly comfortable blind in a tree, incorporating existing branches into the design.

The third setup, using a remote triggering device, is not as satisfying to me from a photographic standpoint, because I never get to see the birds in my viewfinder. You just prefocus, preframe, and shoot when a bird lands in the nest. It's all hit or miss and you don't know what you have until you get your film back from the lab. I prefer to take pictures "consciously" whenever possible—composing an image I want in my viewfinder and firing my shutter at the perfect moment to create the image I'm after. Otherwise I feel like the picture was taken by a robot

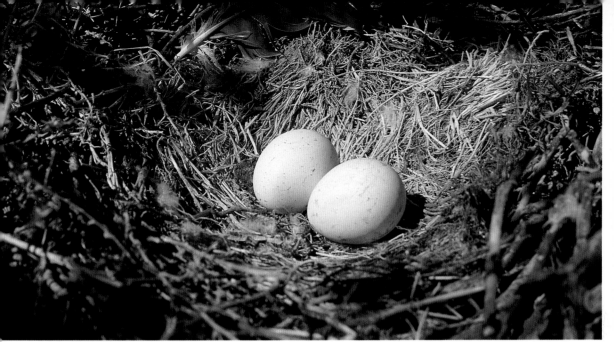

I don't usually like static shots of eggs in a nest, but I'm pleased with this picture of a Swainson's hawk nest. Although the center of interest is smack dab in the middle, which is usually a boring composition, the soft lighting and the way the nest twigs and the feather frame the eggs in a swirl add enough visual interest to make this a good photograph.

with very little input from me. Still, if that's the only way to get a picture, I'll do it. And it really is the best way to photograph songbird nests.

Perhaps you'd like to try a remote-triggering device for photographing the blue jay or robin nest in your backyard, or the pair of warblers in the woods down the street. This is an entirely different kind of bird photography, almost like a modified studio setup. Since these birds usually nest deep in foliage, artificial lighting is pretty much a necessity. Most photographers use two flashes for this kind of work—one the key light, which provides the bulk of the illumination, and the other the fill light, which is mostly to get rid of the shadows caused by the other flash. These flashes are placed on opposite sides of the camera, both of them positioned at about a forty-five degree angle from the line of sight between the camera lens and the subject. There should be a three to one ratio between the two flashes—that is, the key light should put out three times the light as the fill light. You can accomplish this by adjusting the manual controls on the two strobes or by moving the fill light farther back.

It's best to experiment with your lighting setup before trying it out on an active nest. Shoot a couple of rolls of an empty nest or some other object in the shrubbery. Be sure to take extensive notes on your camera and strobe settings. Look closely at your finished slides and decide what settings and lighting angles work best for you. Then you'll have a good idea how to set up your lights on an actual bird nest.

Using a remote-triggering device does give you the opportunity to move your camera fairly close to your subject—so close, in fact, that you won't need a telephoto lens. Using a 50mm or other short-focal-length lens really boosts your depth of field.

Birds seem to get used to the flash of the strobes quickly. My only complaint about this kind of photography is that many of the pictures have an artificial look. It's hard to avoid that when you're using electronic flashes as your primary light source. If you point one strobe directly at your subject, you get a one-dimensional effect. If you use a key light and a fill light as I've described, the birds invariably have two catch lights in their eyes. Using one light positioned a little higher than the camera and to one side provides a somewhat more natural look, though you might have some harsh shadows. Experiment a little. See what works best for you. There's really no other way to get decent nesting shots of woodland songbirds.

6

BE PREPARED

PHOTOGRAPHING BIRDS can be the most frustrating thing in the world at times. You spend weeks trying to get close-up shots of an elusive songbird species. You try everything—going to the field before dawn, hiding in a stifling blind all day, playing recorded birdsongs—all to no avail. Then, the very next time you take your family out for a picnic, one of the damn birds shows up. It's all over you, sitting in a low bush next to you, hopping around on the grass, even landing on the table right under your face trying to steal cookie crumbs. Of course, your camera is fifty miles away, sitting on your kitchen table. It's a painful lesson, but all wildlife photographers learn it eventually. In this game you must always be prepared for the unexpected.

But what can you do to be ready for those great moments when everything comes together like magic? The most important thing is to have your major items of equipment close at hand where you'll always be able to get to them in a hurry. I keep a small daypack ready at all times, loaded with all the equipment I'll need for impromptu bird photography. The main item is my 400mm lens, already attached to a camera body. And I always keep a quick-release tripod mount screwed onto the lens. If an interesting subject turns up, it only takes a minute to get the camera and lens out, mount it on a tripod, and start shooting.

In addition to my 400mm lens, I keep an 80–200mm zoom lens and

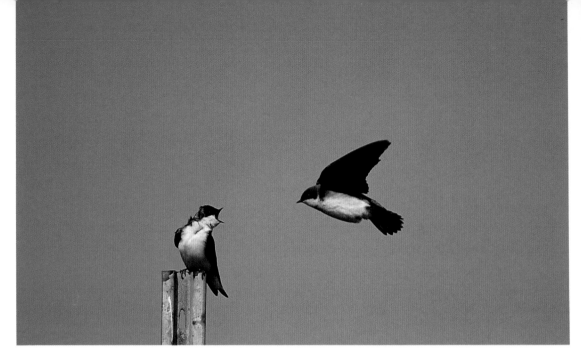

Always be ready for unexpected and interesting bird behavior. I saw these tree swallows engaged in aerial skirmishes with each other. Occasionally one would land and the other would dive at it.

a 28–80mm wide-angle zoom lens. With this pack, and the tripod I always keep behind the seat of my pickup truck, I'm ready for a wide range of photographic possibilities.

A pack may not be the way to go for you. Some camera bags are excellent, offering a wide range of compartments for storing lenses and extra camera bodies. I own a bag manufactured by Orvis that is very handy. It was actually designed for carrying fishing equipment, but it makes a perfect camera bag—waterproof, padded, and with plenty of convenient outside pockets. While I'm mentioning fishing equipment, you might want to try a fly fisherman-type vest, some of which are made specifically for photography. The numerous pockets on the front of a vest will hold a lot of film and equipment. You can even fit an extra camera body into each of the large lower pockets on the front. Many photographer's vests have a useful combination of pockets on the back: a stuff pocket large enough to hold a compact rain poncho, and an exterior pocket that runs diagonally across the wearer's back to accommodate a small tripod.

When using a camera bag, a daypack, or a vest, the trick is to assign specific pockets for different items and never vary the order. Develop a

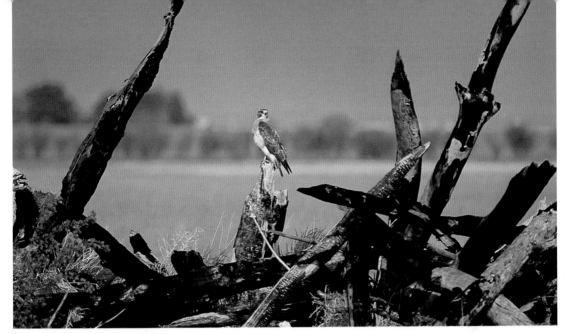

My camera equipment was ready on the car seat beside me when I spotted this adult Swainson's hawk perched along the interstate. Framing your subject with foreground objects, such as these burnt timbers, can sometimes create an attractive composition.

system that works for you, then stay with it. A light meter pocket should always hold a light meter; a film pocket should always hold film. As the old carpenter said, "Keep a place for every tool, and keep every tool in its place." If you obey that maxim, you'll never have to search for something at a crucial moment.

But there's more to readiness than just having your equipment there when you need it. You must always be sure that your equipment is fully functional and ready to use. Every photographer has been burned at one time or another by equipment failure. And it always seems to happen at the worst possible time.

To illustrate the point, let me share a couple of horror stories of my own. Picture, if you will: I'm sitting in a blind alone in a marsh, taking pictures of some blue-winged teal preening next to a small pond. Everything is going great. I've already shot a few rolls of film. The light is perfect. The camera is working well. Suddenly, the birds tense up, then scramble into the water. Anticipating a possible predator attack, I loosen the ball-joint head on my tripod slightly and watch intently.

At that moment, a merlin comes tearing into view, in hot pursuit of a small songbird. As the smaller bird crashes into cover, the merlin

pulls up sharply and hangs in the air for a long moment right in front of me. I swing my lens up along with the action, focus, and squeeze the release on my motordrive as the merlin stalls, hung in the air. In that brief instant, I see a fantastic picture of a merlin in my viewfinder. But, alas, the photograph was not to be. Instead of hearing the merry whir of my motordrive, all I hear is a dull, depressing buzz.

The problem: The battery powering my camera's electronic shutter had chosen this moment to quit. To say that this was an inopportune moment for the battery to fail would be a pathetic understatement. Anyway, it was all my fault. I had violated the cardinal rule of not changing or testing my batteries often enough. This battery had been in my camera body for over a year. I had saved myself a couple of dollars by keeping an old battery, but at the expense of losing a photographic opportunity that might never be repeated in my entire lifetime. Now I have a battery tester and I check my batteries often. If a battery is marginal, I chuck it.

Horror story number two: I was walking around a local marsh one dark and rainy winter morning, hoping to find something worth photographing. The drizzle was incessant—miserable for photographer and equipment. I wasn't seeing anything worth wasting film on and was about to call it quits, when I spotted a bird in a small ditch next to some dense cover at the edge of a dirt road. It was a clapper rail. Not that the bird is the rarest species around, but they're very secretive. It's hard to get a good close-up picture of a clapper rail without having reeds or other cover blocking part of the view. Anyway, this bird was standing statuelike only ten feet away from me, perhaps not sure whether it had been spotted.

I slowly set up my camera and tripod. Taking a light meter reading with my camera I saw that the fastest shutter speed I could use with the lens wide open was a molasses-slow 1/8th of a second. Luckily, the bird was standing completely still. I locked up the mirror on my camera and used the shutter release timer to eliminate the possibility of any camera tremor as the shutter fired.

I couldn't believe how well it was working. The bird completely filled the frame. I shot several photographs. Then I used an even slower shutter speed so that I could use a smaller aperture opening, gaining greater depth of field. After that I slowly held out my hand, then

snapped my fingers to get the bird's attention. Obligingly, it moved its head to look in the direction of my hand, then froze again, giving me a perfect profile.

I shot several more frames of the bird. Finally, as the rain started pelting down in buckets, I carefully packed up my equipment and slipped away without ever really disturbing the bird.

I was grinning from ear to ear as I went home and started to take the film out of my camera. As I cranked the take-up spool, the grim truth became apparent: There was no film in the camera.

This story actually doesn't fit well in the equipment failure category, unless you classify my brain as an article of equipment. I don't know how it happened. I've always made a point of reloading my camera every time I run out of film, but somehow, at this crucial time, I'd forgotten.

All I have left from these two experiences are some beautiful mental images of some photographs that were never to be. Who knows whether the photographs would have turned out anything like the way I envisioned them? Perhaps they would have ended up in the cull file anyway. As it is, these images will lurk forever somewhere in my mind's eye, just barely out of reach, and like the legendary fish that got away, will grow grander and more perfect as time goes on.

At least I learned some valuable object lessons from these experiences. Number one: Whenever you pick up your camera before a photo shoot, always turn the rewind knob slightly, just enough to feel the resistance that tells you there's film inside. Number two: Keep a written record of the date when you install new batteries in your camera, and always replace those batteries in a timely fashion.

I keep spare batteries on hand at all times now, stored in dime-sized, clear-plastic coin tubes (available at most coin stores). You can put a cotton ball between each of the batteries in the tube to keep them from touching. It's also wise to take your battery out periodically and clean it, as well as the camera's battery holder. Sometimes a deposit forms that can interfere with the flow of electricity into the camera. If you're going to store your camera for a month or more, remove the batteries and store them separately. Just be sure to reinstall them before you go out on your next photographic excursion!

To be ready for all the freak photographic opportunities that might

BOUNDARY
ECOLOGICAL
RESERVE
STATE OF CALIFORNIA
THE RESOURCES AGENCY
DEPARTMENT OF FISH & GAME

UPPER NEWPORT BAY
ECOLOGICAL RESERVE
PROTECT YOUR WILDLIFE BY OBSERVING THESE RULES

YOU CAN

turn up, always carry along several rolls of film. In addition to the four or five rolls in my daypack, I sometimes carry extra rolls in a small ice chest to keep them cool. If it looks as though I'll need more film, I take a few rolls from the ice chest and let them sit for an hour or two before loading them into my camera.

If you're about to go into the field and you see that the roll of film in your camera has only five or six shots left, it's a good idea to spool in the film and replace it with a fresh roll. Nothing's more annoying than getting into a good photographic situation and finding that after taking a couple of shots you have to change film. The fuss of loading film is sometimes enough to frighten off a wary bird. One way to avoid the hassle of changing film at inopportune moments is to carry one or two extra camera bodies, preloaded with film. With bayonet-mounted lenses, it only takes a second to switch camera bodies. Then you can reload the first camera at a more convenient time.

Bird photography is never really easy, but if you're always prepared, you can be sure you'll be ready when those wonderful photographic opportunities come your way.

Humor adds interest to a picture. This red-tailed hawk (left) made me laugh when I saw it "standing guard" at the edge of the wildlife sanctuary.

7

ELEMENTS OF COMPOSITION

PROBABLY NOTHING IN THE field of photography is more difficult to explain than how to create a great picture. You can recommend equipment, show how to figure out the correct exposure, provide plans for building blinds, but there's an added element to photography that defies an easy formula. It involves having an eye for composition, a feel for color and shape, and more. Anyone can take "field guide" shots of birds—the kind of pictures that illustrate identification characteristics of a species—but it takes a special knack to turn the image of a bird in your viewfinder into a work of art.

Some people are blessed with an artist's eye. They don't have to think about any rules or guidelines for effective composition; they visualize a great picture and then shoot it. The rest of us must learn the hard way—by reading "how-to" books, by studying the work of photographers we admire, and by trial and error as we take our own pictures. My photography teacher in high school had an interesting method of teaching his students about composition: He took us to art museums where we studied classic paintings, illustrations, and even sculptures. He reasoned that these other art forms, in which the artist

has complete control over lighting, shape, texture, and color, would provide a more graphic example than a photograph of the principles of composition. We saw how Rembrandt used light and shadow to create drama in his paintings; how Picasso used geometric shapes, colors, and skewed perspectives to show us another way of looking at the world; and how Michelangelo achieved perfection of form and balance in a statue. Later in class, our teacher would project slides of the works we'd seen and quiz us on what the artist was trying to achieve: What is the point of interest? How is it emphasized?

I wouldn't necessarily encourage you to spend hours in an art museum poring over paintings—though that couldn't hurt—but I do think you should look at a lot of wildlife photographs. Pick up some magazines and go through them slowly, scrutinizing every picture. Which ones appeal to you? Why do you like these particular shots? What can you do in your own pictures to re-create the effects that these photographers have achieved? If you can answer these questions, it will help you to progress as a photographer.

Bird photographers take their greatest pictures when they've gone beyond the point of having to think about composition—they have an intimate knowledge of the species they're photographing and an intuitive feel for how best to illustrate the things that make this bird unique. However, there are some basic guidelines you should know up front as you start taking pictures of birds. Most of them are simple and will soon become second nature to you.

To begin with, let's look at the elements that you have to work with. Foremost among them is light—the angle, the intensity, the hue of your light source can make or break a picture. The most pleasing natural light occurs in the morning and late afternoon. The angle of the light is perfect and the sunlight is warm and subdued, bringing out all the color and texture of your subject's plumage. At midday on a bright, clear day it's hard to take a good photograph. The sun is at its zenith, in terms of its angle in the sky and its intensity. Pictures taken in these conditions have too much contrast, with washed-out light-colored areas and black shadows. On bright days with intermittent clouds, you sometimes have moments when a cloud passes over the sun, for a short time diffusing the light and eliminating harsh shadows even at midday. On overcast days, you can often shoot throughout the day, though the

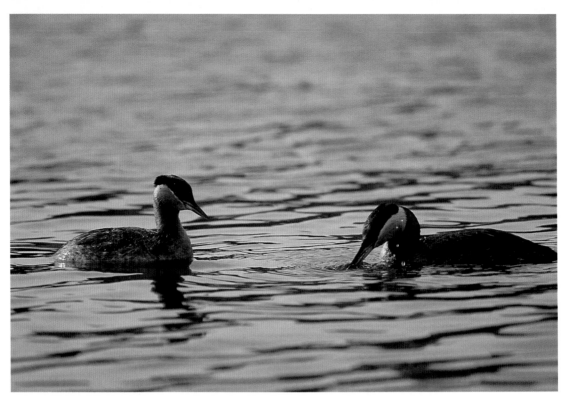

What a difference quality of light can make. I once spent several days photographing red-necked grebes (pages 74–76) under lead-gray skies. The first photographs I took were sharp and captured interesting behavior, but they lacked vivid color and warmth.

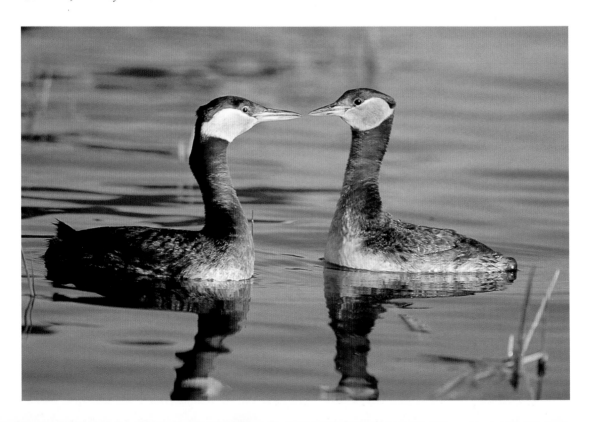

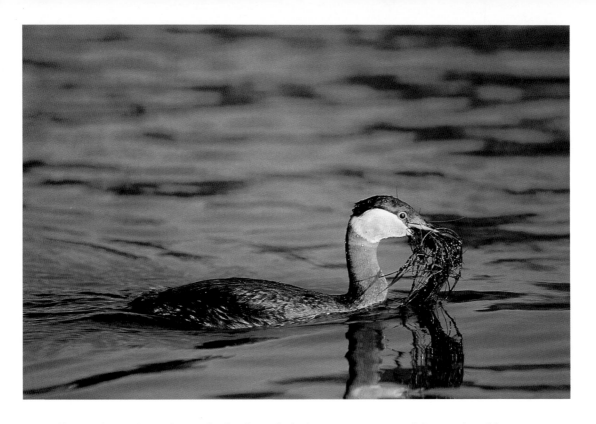

Finally, one day at dawn the sun broke through the haze, creating one of those rich, golden mornings that photographers dream about.

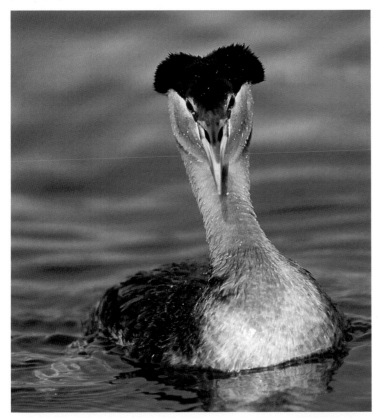

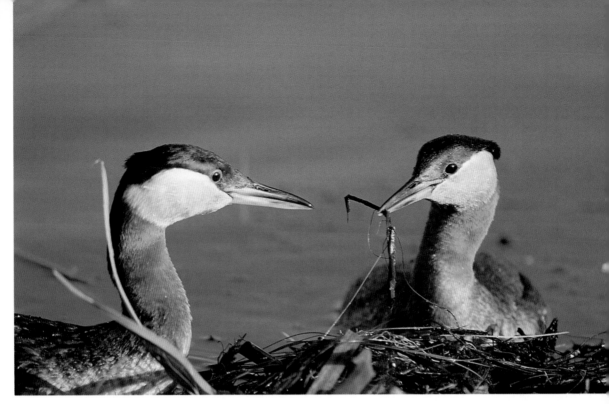

The warm, even light set the grebes aglow, showing the full glory of their nuptial plumage as they courted.

colors are never as vivid as on those golden mornings and afternoons with soft, warm light.

I prefer to take pictures with the sun behind me—not directly at my back, which tends to create a flat image of the bird, but to one side so that the bird casts a shadow; this adds a three-dimensional quality to a picture. It's much more difficult to take a good picture of a backlit bird, unless you just want a silhouette of your subject. Silhouettes are relatively easy to achieve: Just aim your camera directly at the beautiful sunset-filled sky behind the bird to take your light-meter reading, set the camera manually, then frame your shot to include the great blue heron in the foreground. You should end up with an attractive, completely black image of the bird in front of a gorgeous sky. To get more than a silhouette from a backlit bird, you'll need to open up your camera's aperture (or slow the shutter speed) at least a couple of stops beyond the exposure settings you used to achieve the silhouette effect. (Remember, the lower your f/stop number, the more open the aperture is.) The image still may be unacceptable, either too dark or too washed-out–looking, but occasionally you get a great picture of a backlit bird, beautifully haloed by the sun. I sometimes use a flash to help bring out

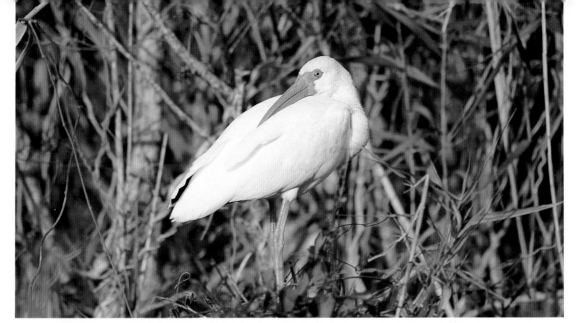

Light meters tend to give average readings in the mid-range between the light and dark elements of your composition. This usually works fine, but if your subject is a white bird against a dark background, you may get an incorrect exposure reading, and the bird might appear washed out. To capture the subtle feather detail of this white ibis, I overrode my camera's light meter and let in two more f/stops of light.

a little more detail on the bird, but it's still hard to get the kind of picture I want in this kind of light.

The way light reflects off certain colors, particularly white, can make it difficult to obtain a correct exposure. Most light meters built into cameras tend to give a reading that averages in all the various light and dark elements in the scene you're about to photograph. This works well in most situations, but there are times when it fails miserably. Say that you're photographing a snowy egret against a drab background. You don't care how light or dark this background looks in your picture—all that matters is that the egret is correctly exposed—but your camera's light meter is trying to balance the bright white of the egret with the drab background. To overcome this problem in photographing white birds, I put my camera in the manual-exposure-setting mode, take a reading off the background, then open up the aperture two f/stops.

Many photographers "bracket" their exposures in difficult lighting situations to increase their chances of producing a usable photograph. For example, say that your camera's light meter indicates that the optimum exposure for a particular shot is 1/125th of second at f/8; to

bracket, you would shoot one picture at that setting, another picture using one f/stop less light (f/11), and still another using one stop more light than f/8 (f/5.6). Some photographers take even more than three shots of a given image, varying the f/stop or shutter speed each time. The idea is to get at least one great, perfectly exposed image in a difficult lighting situation. Of course, it takes a pretty cooperative bird to let you take multiple shots like that.

Another important compositional element is the framing of a picture. How can you make the best use of the potential picture that lies before you? Should you position the bird at the center of the viewfinder, or would the shot be more dynamic if you shifted your point of view to one side or the other, or up or down? Should you move in closer to your subject (or use a more powerful lens), or would the picture be more visually interesting if you backed off and included more of the vegetation? These are important questions, and how you deal with them determines to a large extent whether your picture will be ordinary or great.

As a general rule, pictures with the point of interest placed dead center tend to be boring. When we view a picture, our eyes are naturally drawn to the center. If the bird is stuck right there, we have no reason to look anywhere else in the picture, and we quickly become tired of the image, whereas if, for example, the bird is at the left side of a horizontal picture, looking toward the right, we create a dynamic interplay in which our vision is drawn repeatedly from the bird to the center in a circular motion. Always try to frame the shot so that the bird is looking into the picture. It looks odd if the bird is right up against the side, staring at the edge of the picture. If the bird is flying, have plenty of space in front of it, so that it appears the bird has somewhere to go.

Other objects framed in your picture can improve or detract from its composition. Branches, shrubbery, rocks, and other things around the bird can be distracting. I know it's sometimes hard to keep track of the foreground and background when you're doing a major juggling act just trying to follow a bird and keep it in focus, but it's important to make sure that you don't ruin a shot by having a branch right behind the bird that looks like it's growing out of the bird's head, or a piece of trash sitting in plain view.

Try to take a second to evaluate a shot before you snap the shutter.

Does the tangle of shrubbery behind the bird clutter the picture? Try zooming in on the bird to eliminate some of the background. Or open up your aperture more, which can turn the background into an out-of-focus blur. Are there any other potentially distracting things near the bird? Perhaps a brightly colored flower? Maybe you can change your angle a little and eliminate the flower. Or, better yet, figure out an interesting way to incorporate it into your picture. Maybe the large, diagonal branch that's bothering you would look great, adding texture to your photograph and leading the viewer's eye to the bird, if you moved over a few feet or raised your camera more. I think pictures of birds are always infinitely better if you can find creative ways to incorporate the bird's habitat into the shot.

Related to framing is camera angle. How low or high you position your camera is especially significant. If you're taking pictures of shorebirds, for example, and you're shooting down at them from your full height, I don't think you can adequately convey what it is to be a shorebird. You need to lie down in the mud with them, eye to eye. Sometimes it's impossible to get on the same level as a bird, especially if it's up in the treetops, but it's always something you should strive for.

The strong diagonal line of the branch, soft lighting, and the way the loggerhead shrike looks back into the picture make this a successful composition; if the bird had turned its head to look forward, it would have seemed too close to the left edge of the photograph.

This American avocet is in sharp focus and properly exposed, but the horizon line is noticeably crooked. Always check position of the horizon before shooting. If you have trouble judging the horizon angle, install a focusing screen in your camera with a grid pattern etched on it.

Having a tilted horizon line in your picture is a common pitfall. I've been guilty of this many times. I had my camera on a bird, the focus was perfect, but I didn't take the time to make sure the horizon was parallel with the bottom of the picture. This is annoying. Though in some cases a magazine's art director can crop the shot to align the horizon, you're much less likely to be able to sell a photograph like that. I've solved the problem by installing in my camera a new focusing screen with a grid etched on it. I always try to check the alignment of the horizon with one of the grid lines before snapping a picture. Another thing to avoid is placing the horizon line in the middle of the picture. This cuts the picture in half and usually looks terrible, unless you're shooting a reflection of a bird in water. It's better to frame the horizon line in the top or bottom third of your photograph, or change your camera angle to eliminate it completely.

Focus is a major element in photographic design. I've already mentioned how you can make a background less intrusive by using a wider aperture setting. This is especially effective using long telephoto lenses, which always provide less depth of field than shorter lenses. You can use focus to isolate one bird in a massive flock or perhaps one body

part of a single bird. Sometimes it's impossible to get an entire bird in focus. When in doubt, always focus on the eye—the window to the inner life of any living thing. You may not necessarily end up with a great shot if just the eye is in focus, but I guarantee if the eye is not in focus, the shot will definitely be a reject.

One thing to keep in mind about focus: The apertures of most modern cameras are kept in fully open position right up until the moment you press the shutter release, at which time they close down to the correct setting. They were designed like this to give a photographer maximum light while framing and focusing a picture. But when the aperture closes down, it greatly increases the depth of field—the area in sharp focus—of a picture. Most professional-quality 35mm cameras have a depth-of-field preview button that you can depress to see exactly what will be in focus in your photograph. The image you see when you hold the button down will be darker than usual, but unless you're shooting at one of your smallest f/stop settings, you should be able to see well enough to check your focus.

You have all these elements to work with in creating the image you're after: light and shadow, framing, camera angle, and focus, as

In your photographs strive to tell as much as you can about a species. In this series (pages 81–84) I tried to capture the essence of the prairie falcons' existence—the harsh, arid lands they inhabit, where survival is a constant struggle . . .

...the lofty, windswept crags they choose as eyries...

well as color, shape, texture, motion, and more. These are your raw materials. How you employ them is what sets your work apart from everyone else's. The key to improving as a bird photographer is to spend a lot of time in the field and shoot plenty of film. But do take the time to think about what you're doing. Don't take a complete "shot-gun" approach, shooting thousands of frames and seeing if anything turns out. Try to make every trip into the field a learning experience. Get a small writing pad and take notes as you try different exposures and techniques. Always look at your slides closely when you get them back from the lab—even the rejects. You can often learn a lot from a bad picture and avoid repeating your mistakes.

Learn to work an area thoroughly when you're taking pictures. Shoot wide-angle scenic shots, then move in on particular habitats—marshy edges, cattails, shrubbery, woodlands, open water. Next take pictures of groups and individual birds. As you approach a bird, work on getting a variety of shots. Start with more distant shots of the bird, including habitat in the picture. Though many magazines prefer to publish extreme close-up pictures of birds, more and more are looking for shots that emphasize the fact that the bird is an integral part of a

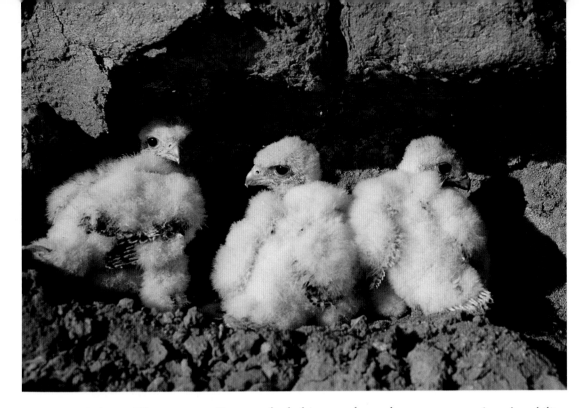

particular habitat. The message: Destroy the habitat, and you destroy the bird.

Try varying your compositions between vertical and horizontal formats. Magazine cover photographs are generally shot in a vertical format. Inside photographs can be vertical or horizontal, but the big two-page spreads that pay so well are always horizontal. By varying between vertical and horizontal compositions, you increase your chances of making a sale. Also, some magazines, most notably *Audubon*, use a horizontal cover shot that wraps around to the back cover. Think about which magazines you are aiming for when you shoot a possible cover. Most cover shots must have empty space above the subject's head to accommodate the magazine's logo. If the publisher runs blurbs on the cover advertising the features inside the issue, the picture will need space along the side to accommodate them.

When you're photographing a particular species, try to get the full life history of the bird in pictures. Think like a film director when you're out on a shoot. Always strive to tell a story with your pictures. Every shot can be loaded with visual information, capturing the essence of a bird's behavior. Ask yourself: How can I show what this

. . . the vulnerability of their downy nestlings . . .

ELEMENTS OF
COMPOSITION

83

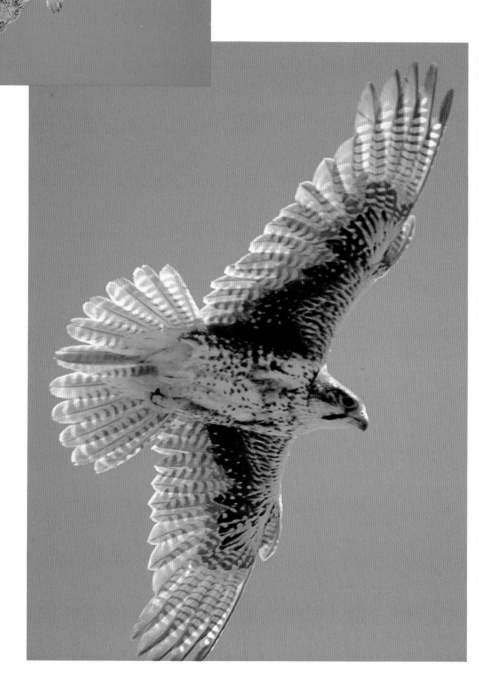

...and most of all, the power of their flight.

bird's life is really like? Think of an establishing shot: a grand, wide-angle view of a distant butte, the lofty home of a prairie falcon pair. Move in closer to see the rocky crag where the birds nest, the ledges streaked white where the birds perch. Move closer still. Show the birds on their nest ledge. You know these birds. You've studied their species in books. You've spent weeks with them on their home ground and watched them raise their young. Tell their story. Celebrate the falcons in your photographs. Share their lives with others so that they too can appreciate the birds' existence.

Constantly experiment with your photography. Find out what works for you. Put your own mark on your work. A good picture tells a lot about the person who took it. It can capture your sense of humor, your empathy for the subject, perhaps even your outlook on life. No one sees things in quite the same way as you. Always strive to be original in your picture taking. Photograph birds from new and different angles. Lie down in the mud if necessary to get the picture that tells it all. Try some unusual lighting situations. Above all, try to catch your subjects engaged in an interesting activity—preening, singing, feeding, flying, fighting—anything but just sitting around looking pretty. With a little extra thought and effort, you can take pictures that you'll be proud of.

8

WHERE TO
PHOTOGRAPH BIRDS

BACKYARDS

WHAT COULD BE MORE enjoyable than looking out your window at a flock of songbirds taking a meal at your backyard feeder? It's a chance to see shy species up close and relaxed in an environment they fully trust. A bird-feeder can also provide a great opportunity to photograph birds, without having to carefully stalk your subject or spend hours in a blind.

Backyard bird photography is potentially one of the easiest and most rewarding forms of nature photography because you never have to leave home. Your house is a perfect blind, and you can manipulate the habitat in your yard any way you want to make photography easier. Is the available light too low or uneven? Move the feeder to a more brightly lit area. Are there branches or shrubbery in the way? Get out your shears and prune them back. You are master of the setting, arranging background objects and props like a film director for optimum lighting, composition, and image size.

If your bird-feeder is close to a window, you can start taking pictures immediately without making any elaborate preparations. I always

open the window rather than attempt to shoot through the glass. Even if your window glass is impeccably clean, you run the risk of glare or imperfections in the nonoptical glass that can affect your image quality. If it's too cold outside to leave the window open or if the open window frightens birds, make a simple cardboard or wood window cover with a hole cut out for your lens.

At home, you can leave your camera set up for long periods in one spot. Whenever the birds come to your feeder in force, just frame your shot, check your exposure and focus, then fire away.

If your feeder is well established with the birds in your yard but is situated in a bad location for photography, gradually move it closer to your window. It may take several days to get it where you want it, but most birds adapt easily to a new feeder location.

Another tactic is to set up your equipment near your feeder and trigger the camera from inside your house, using a long shutter-release cable or a remote control unit. To accomplish this you must have a camera with a motordrive or an autowinder. Otherwise you'll need to walk out to the camera and advance the film after every shot. You won't be able to go out and refocus the camera either, so it's important to prefocus accurately. Select a place on your feeder where you expect a bird to sit, then focus on it. Whenever a bird lands in the right spot, trigger the camera, and you should end up with a perfectly focused picture of a feeding bird. Some auto-exposure, autofocus cameras are ideal for remote photography, compensating for rapidly changing light conditions and subject distances.

The most inexpensive way to trip your camera from a remote location is to use a long shutter-release tube with a rubber air bulb at one end. It's primitive but effective. You squeeze the bulb and a blast of air travels all the way to your camera and triggers the shutter. If the tube is long, though, you might get a delayed reaction or misfires. I've seen photographers replace the bulb at the end of the tube with a foot-pedal-type bicycle pump. This really delivers a powerful blast of air and will trigger the shutter quite well, provided that the tube doesn't burst.

If you want something more elaborate than an air-bulb shutter release, your local camera store will be glad to accommodate you . . . for a price. You can choose between radio-controlled or infrared remote units, or even devices that project a beam of light that if crossed by a

Cut a groove in a log on the opposite side from your camera. Place seed in it to attract birds.

This makes a natural-looking shot which doesn't look like a birdfeeder.

Either place the log on the ground or raise it up on stands or sawhorses.

Place a cardboard or styrofoam insert—with a hole cut in it to accommodate your lens—into your open window to hide your presence and keep the cold out.

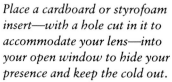

bird will trigger your camera. Take your pick—whatever your bankroll can afford.

Once you've mastered the art of photographing birds at your feeder, you may want to try getting some shots using a more natural background. One way to accomplish this is to create different kinds of feeders from common objects found in fields and woodlots. Get a log and set it on its side in your backyard. With a wood gouge, dig a small hole near the top of the log on the side away from where your camera is set up, then fill it with seed. Birds will eventually accept this as a feeding site. It's then fairly easy to snap pictures of birds as they land on the log and make their way to the seed. This creates a natural-looking picture with minimal effort. Or you can simply sprinkle seed on the ground and photograph the birds that feed there.

Birdbaths are also great for attracting birds, especially in dry climates. With the proper setup, you can take excellent photographs of birds splashing around in water, or sunning themselves after a bath.

You may find that you have problems with some of the more timid bird species when you set up your camera close to a feeder or birdbath. If you could leave your camera out long enough, the birds would become completely used to it, but who wants to leave expensive equipment outside for days at a time? Instead, simply build a dummy camera and set it up in the same location where you'll later place your camera. It doesn't have to look good. Just make a small camera-shaped box, attach an empty juice can to the front of it for a lens, spray paint it black, and there you have it—a dummy camera fit to fool any songbird.

CITY PARKS

Venturing out from your backyard, the next logical place to photograph birds is your local city park. It doesn't matter how big your city is or how small the park; it *will* attract birds. In fact, sometimes a tiny park lodged in the midst of skyscrapers and massive urban development is just the ticket for bird photography. The area surrounding the park is so inhospitable to wildlife that any birds passing through are bound to congregate in this tiny green spot. A park can be like an oasis in a desert of concrete and steel.

There's no limit to the types and species of birds you might see in a

park. Many parks have duck ponds that draw in most of the waterfowl species passing through your area. And if the pond has some tame ducks, so much the better. Live ducks are the best possible decoys for attracting their wild cousins, which is the reason why the practice of using live decoys for hunting was abolished years ago.

Park ponds also attract wading birds—herons, egrets, night-herons. These birds and the migrating waterfowl are generally much less suspicious of people in a park than they would be in almost any other area. The constant exposure to human beings who never harm them (and often try to feed them) has a gradual taming effect. The birds drop some of their natural caution.

A tiny park sits in the middle of the city where I used to live. It's a fairly typical urban American park, with the obligatory duck pond, shade trees, and lush green grass. What makes it remarkable is the variety of bird life it attracts: hummingbirds, warblers, sparrows, blackbirds, doves, tanagers, hawks, owls, and assorted waterfowl.

I started visiting the park several years ago and I still drop by whenever I go back home for a visit. I used to spend my lunch hours there to get away from the office. It never occurred to me at first to bring a camera with me. Then I started noticing all the interesting birds, and I saw how approachable they were. A squadron of Canada geese would show up most days, looking as massive and heavy as World War II bombers as they sailed in, flaps down, and splashed heavily into the water. In winter the geese were joined by other waterfowl—wigeon, mallards, ruddy ducks, coots—a true bounty for a bird photographer.

People are always milling around the sides of park ponds, sitting on benches, or feeding pigeons or domestic ducks. The wild ducks are easy to distinguish from their domestic counterparts. They are sleeker, their colors are more distinct, and they tend to stay at the periphery of the tame flock, farthest from the people.

If you spend a couple of hours seated beside a park pond with your camera and tripod set up, you should be able to take some good pictures. Just be sure to focus only on the wild ducks. And always keep an eye on where the tame ducks are. They have an annoying habit of stepping in front of the camera just at the instant you're squeezing off a shot.

To make the best use of a city park pond, make yourself a little less conspicuous than the typical park visitor. Try sitting on the ground,

preferably next to a tree or bench so you won't stand out as much. Keep as motionless as possible. The ducks can still see you, but the point is to be nonthreatening. The longer you sit still, the more you'll blend into the background.

Your choice of a sitting spot is important. I prefer places less frequented by other park visitors. Then people won't be coming by and disturbing the birds every five minutes. Try to find a spot that's directly across the pond from an area with a lot of human activity. That way, whenever people are over there, the wild ducks will tend to drift away from them (and closer to you).

I always move slowly and smoothly when I work a pond. It pays off. Birds often seem oblivious to my presence. They take splash baths, they preen, they sun themselves, all within easy camera range. When I think of all the times I've waited for hours in blinds or slid on my belly through mud to get close to some of these species, it makes me laugh. At a park, if I'm quiet and patient, they practically walk up and pose for me.

City parks are also among the best places to take flight shots of ducks. During the day, the wild ducks are occasionally spooked by people. They usually circle around for a while, then return to the pond. When they're taking off and also when they're backpaddling to land, it's less difficult than usual to take good flight shots. At these times, the ducks are flying more slowly than usual, which makes it easier to follow the birds and focus your camera accurately. If the body is sharp, but the wings are blurred, so much the better. This only accentuates the sense of motion of the bird in flight.

Other interesting picture opportunities pop up from time to time at parks. One morning after a rain, a group of long-billed curlews showed up at my local park, probing around on the lawn with their impossibly long, decurved bills. Like the other birds, they were remarkably tame. I rolled up quietly next to them in my car on a road at the edge of the park, and shot close-up portraits of them until I ran out of film. You never know what might show up at a city park.

ON THE BEACH

Whether you live on the Atlantic or Pacific coast, beside the Gulf of Mexico, or along a lake or river with a sandy shoreline, your nearby

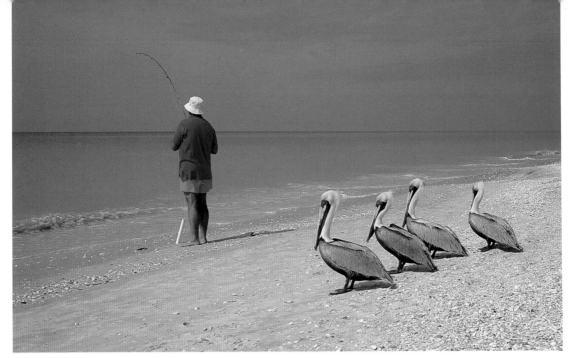

The constant presence of humans at the beach has a taming effect on birds. Here, an angler stoically fishes at the edge of the shore, completely oblivious to the brown pelicans lined up four deep behind him.

beaches can provide excellent locales for close-up bird photography. Where else are shorebirds, gulls, terns, and other interesting birds so plentiful and easy to approach?

I spent many years photographing birds on the beaches of Southern California. I found a diverse selection of subjects—brown pelicans, surf scoters, sanderlings, marbled godwits, whimbrels, and willets, to name a few.

In addition to the birds themselves, the background scenery and the subtle hues of the light at various times of the day can add breathtaking elements to your pictures. On a good morning the rich, low-angled light spills warmly across the beach, illuminating all the feather detail and color of the birds, and the blue of the water behind. At sunset the sky is ablaze with a fiery orange light, reflected in the wet sheen left behind as a wave rolls back. With a background like that, you can't miss taking great pictures.

Beach photography has its own set of tactics and also some problems to overcome. Many beaches have a lot of human traffic. This has its good and bad points. People do scare off birds once in a while. But just like in a city park, the constant presence of people tames the birds

somewhat. And many birds that are flushed by passersby on the beach will return as soon as the people move on.

I never set up a conventional blind at the beach. Blinds draw too much attention. Everyone wants to know what the blind is and what you're doing. The minute you've explained your business to one group and sent it on its way, someone else comes walking over to see what's up.

Instead of setting up a blind, I sometimes build a variation of a sand-castle. Using a small trowel, I pile up a wall of sand with a vee cut in the middle to accommodate my camera and lens. It doesn't have to be large—three feet wide by about a foot high is fine. I always place a towel or piece of tarp under the camera to protect it from the sand. One of the advantages of this setup is that you don't need a tripod. It's easy to make the sand conform to the shape of your equipment, providing excellent support for your telephoto lens. Since half the people at the beach are building a sandcastle or sculpture of some kind, your sand wall should go unnoticed. I've used this technique many times to get close-up shots of shorebirds running up and down the beach. Sanderlings, black-bellied plovers, and willets often walk right up the beach toward me, never suspecting a thing until they hear the whir of my camera's motordrive. And then they usually just stand tall and freeze for a few seconds, which is a good time to snap another picture.

Often you don't even need to use a sand wall at the beach. If the birds are tame enough, just sit or lie down on the sand and wait for the birds to come to you. The most important thing is to figure out where the shorebirds are heading so you can place yourself accordingly. Some shorebirds, especially sanderlings, run quickly after the retreating water as a wave recedes, snatching all the food they can get before the next wave crashes in and drives them away. As they move in and out with the waves, they also move laterally up or down the shore. Figure out which way they're moving, then station yourself ahead of them so that they're coming toward you.

When I lived in California, brown pelicans were among my favorite birds to photograph at the beach. Nothing's quite like seeing a bird as large and ungainly as a pelican nosedive into a school of fish. Terns and gulls often join in on the free-for-all, trying to catch fish (or in the gulls' case, steal them). It all made for some good photography. Surf scoters were also interesting to photograph, though much harder to get close

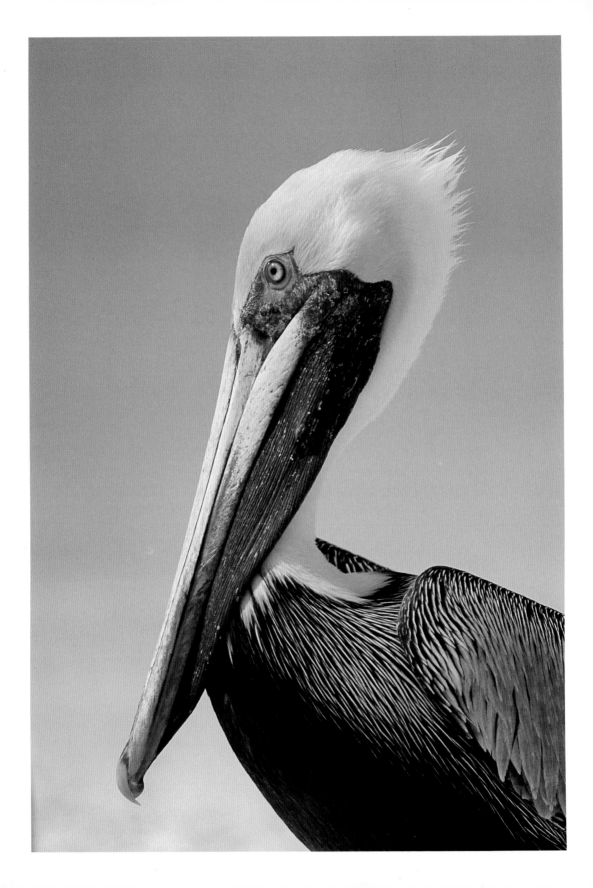

to than the pelicans. They usually stayed pretty far out in the water. I always tried to find them in areas with rocky outcroppings and pools where they would sometimes come close to shore to plunder shellfish. I would hide in the rocks and stay still for as long as possible. Sometimes I got lucky. . . more often, I went home empty-handed.

You can use tidal fluctuations to your advantage when you're photographing at the beach. Study the tide charts. They're available at most coastal bait stores, usually free of charge. Go to the beach and watch how the shoreline changes from low tide to high tide. I remember one place where I often took pictures had a large sand spit with shorebirds scattered loosely over it. As the tide rose, the spit shrunk, compressing all the shorebirds onto a tiny island that stayed above water. I would set my blind on the highest ground at low tide and wait for the birds to be pushed toward me as the tide came in. One word of caution if you try this: Beware of extremely high tides. You may find yourself knee-deep in water at a place that was high and dry during an earlier high tide. Again, check a tide chart.

I photographed this close-up of a brown pelican at a well-populated Florida beach. The bird was so tame, it allowed me to take full frame shots from only six feet away.

Always be extremely cautious with your equipment at the beach. Nothing's more potentially damaging to cameras than the saltwater and sand environment of the seaside. If you ever drop your camera into sea water, you almost might as well leave it there. Cameras can rarely be repaired after they've been dunked in brine. When you're lying down at the water's edge with your attention focused on a flock of sanderlings, it's easy to miss seeing a wave that's about to crash over you.

Salt spray from breaking waves can be just as hard on your camera and lenses if you don't take the time to wipe them off. Sand is also damaging. I avoid the beach if it's windy. Sand can get into the tiniest cracks and crevices of your valuable equipment if a wind stirs it up. Even on a still day you should be careful, especially while changing film. Don't let any sand get inside your camera. Read Chapter 11 for tips on how to protect your camera when shooting in potentially damaging environments.

WETLANDS

Some of the toughest locales for bird photography are wetlands. There you are, crawling through muck for hours, while a dark, brooding au-

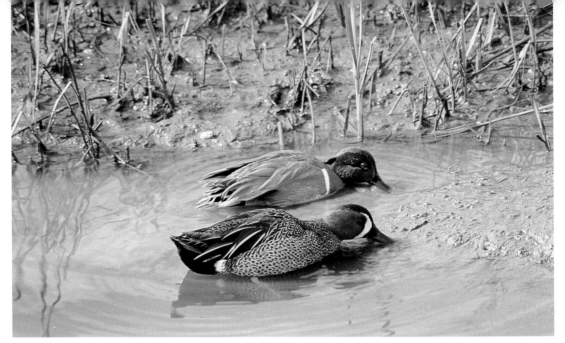

These two drake teals—one a blue-winged, the other a green-winged—were feeding in a shallow slough, and I immediately saw a good opportunity to take a picture that illustrates the differences between the two species, both in size and color.

tumn sky looms menacingly above. The available light is not nearly enough to expose your film properly, and the waterfowl are so spooky, they take off en masse every time you get anywhere close to camera range. Still, despite all the problems, you know you'll be back to try it again another day.

It takes a special kind of person to appreciate a day of taking pictures in a marsh. The photographs often don't turn out as you planned; the tangible rewards are few. So why do it? Why go through all this self-abuse? You may find the answer the first time you take a close-up portrait of a drake green-winged teal with the sunlight catching the brilliant emerald streak across the side of his head. Or a pintail in flight, backpaddling its wings powerfully before alighting on the water. Or a stately great blue heron stalking tiny fish at the edge of the bulrushes. Some of the most beautiful and photogenic birds in the world live in wetlands.

Your choice of wetland has a great bearing on how hard a time you'll have taking pictures. Not all marshes are created equal, at least in a photographic sense. Some bodies of water are too large, making it difficult to get close enough to the birds that live there. Others are too

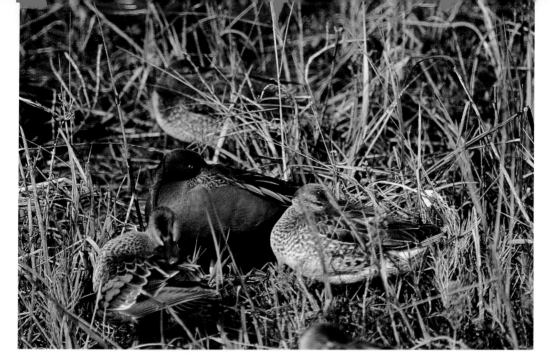

The brilliant colors of this cinnamon teal and its glistening, ruby-red eye make it the center of attention in this group shot of napping ducks.

choked with reeds. Waterfowl hunting areas can be good for photography in the early fall, but during and immediately after hunting season, the ducks and geese there are too spooky to approach.

If you must take pictures in a marsh that's hunted over, plan on going there in the weeks just before hunting season opens. Many state and federal waterfowl areas have permanent blinds set up that photographers can use in the off season. You might even try calling private duck clubs. Some of them allow nonhunters to visit their marshes.

In some situations, you may be able to hide well enough without a blind. Bulrushes and reeds provide good cover if your clothing matches the color of the plants. Wear chest-high waders to keep you dry as you move around the marsh. Dress warmly and wear thermal long underwear under your waders. It's hard to hold your camera steady if your teeth are chattering.

OVERLOOKED LOCALES

Beginning bird photographers often tell me that they don't live in a good enough area to take consistently great shots of wild birds. "If

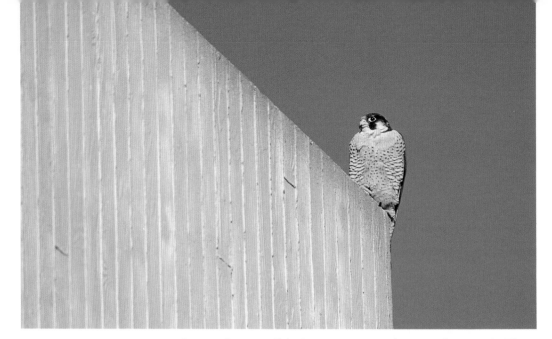

You never know where you'll find an interesting subject to photograph. These peregrine falcons (pages 98–101) were nesting at the top of a tall building in a major urban area.

only I lived in Southern Florida [or one of a dozen other choice areas]," they say, "I'd have all the opportunities I need for fantastic bird photography." The funny thing is that if most of these people went out and looked around a little, they'd probably find hundreds of good sites for bird photography within a few miles of their homes. The trick is to be able to see the potential in the unlikeliest places.

You'd be surprised what a diversity of bird life the empty, overgrown lot down the street or the muddy slough at the end of town will yield if you take a closer look. I've taken some of my best shots in places that most photographers wouldn't give a second glance. I'm always looking for pieces of undeveloped land in the midst of the city—a tiny litter-strewn marsh, a thicket of weeds at the edge of an oilfield, an abandoned woodlot.

In many ways these overlooked places have advantages over wildlife refuges for bird photography. Getting permission to take pictures in an undeveloped field is usually easy, the price of admission is affordable (free), and there are few restrictions. All refuges limit public access in order to protect wildlife and ecosystems; people can go inside only during specified hours and they must stay on trails so they won't tram-

ple down natural vegetation. Many undeveloped or abandoned fields, however, are already deeply scarred with tire tracks and paths. You can go virtually anywhere in such a place without causing further damage to the ecosystem.

Another advantage is that so few people will bother you. When you set up a camera on a trail in a bird sanctuary or wildlife refuge, you face an endless parade of people asking you what you're doing, what kind of bird you're photographing, how big your lens is. They're usually friendly enough, but they break your concentration and often scare away the birds you're trying to photograph. In an undeveloped field, on the other hand, people seldom take the time to walk over and talk to you. I've spent entire days without coming in contact with anyone, even though I was taking pictures less than thirty feet from a busy road.

You can usually get permission to set up a semipermanent blind on undeveloped land—a fantastic aid to bird photography. (Just try setting up a blind at a bird sanctuary.) Since the blind is in place for an extended period, the birds become accustomed to its presence. It's easy to slip into the blind without being noticed.

I wanted to accentuate the incongruity of the situation: a falcon, symbol of everything wild and free . . .

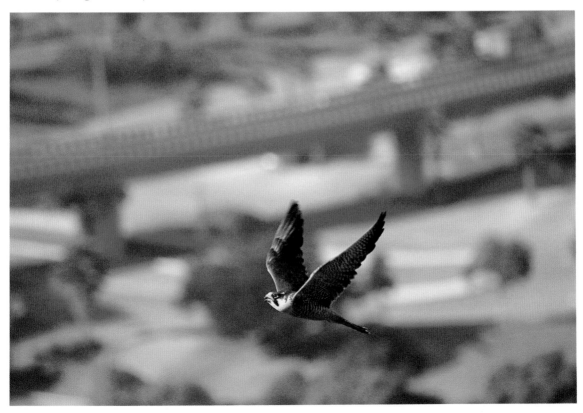

. . . flying against a backdrop of urban clutter, smog, and freeway overpasses.

If you find the right location, you should be able to take some unique photographs. Most birding hot spots have been photographed so extensively that it's difficult to take a really original picture of the habitats or species found there. But if you have your own special field, woodlot, or marsh, you may actually be the first photographer to document the place.

Granted, small undeveloped areas present a few problems for photographers. Buildings, cars, roadways, or utility poles might be visible in the background. The ground may be covered with litter. You can overcome these problems with a little forethought. Take time before you press your shutter release to see if any objectionable items are visible in your viewfinder. If so, try to change the composition to eliminate them. (If you feel energetic, you may even want to pick up some of the litter.) Many offending objects won't even show up; a telephoto lens has a wonderful way of cropping out most of the background or turning it into a pleasing, out-of-focus blur.

One winter I found a nice field while I was driving to a bird sanctuary. I must have driven past the place hundreds of times over the years without ever noticing it. Stuck near the intersection of two major state

Though more falcons have recently begun nesting in cities, I'm still not used to the sight of the world's most spectacular winged predator dashing through skyscraper canyons pursuing its prey.

highways in an urban section of Southern California, the place is easy to miss. I'm sure most people passing by would describe this field as an ugly wasteland just waiting to be developed (if they even noticed it at all). It's bounded by litter-strewn roadways on the south and west sides, an oil company tank farm on the east, and a condominium complex on the north.

Even a sharp-eyed photographer could drive past (as I had done many times) without seeing the beauty that these few precious acres contain. To appreciate the place you must get out of your car, put on your rubber boots, and walk around. I was astounded the first time I did that. I ended up staying for hours. Here were all the elements of a pristine coastal wetland—unique vegetation (pickle weed, bulrushes, cattails, cordgrass, silverweed), mudflats, a small freshwater marsh, and abundant wildlife. Foxes, skunks, weasels, opossums, rabbits, snakes, and small rodents abounded, but the birdlife was even more diverse.

The marsh hosts several species of waterfowl during winter—cinnamon teal, mallard, pintail, wigeon. In addition, great blue herons, avocets, and black-necked stilts forage in the shallows. The mudflat is covered with shorebirds at times. Marsh wrens pop up from the pickle

weed, fly several feet, then drop back down and hide. A red-tailed hawk hunts rodents from a utility pole along the highway. Kestrels hover in the ocean breeze. And I even saw a peregrine falcon there once.

This place has everything that two nearby sanctuaries have, and yet it goes unnoticed (and unprotected). It's an ideal place for photography. Since it's right in the midst of a city, none of the birds are hunted. Consequently, they're fairly unsuspicious. If I spend twenty minutes sitting quietly at the edge of the marsh, the birds get used to me. Black-necked stilts, avocets, snowy egrets, and other wading birds come within ten feet of me as they feed, even when I don't use a blind.

Last spring was a particularly interesting time there. Though the cinnamon teal, the pintails, and the wigeon that wintered in the tiny marsh had already left for their northern breeding grounds, two pairs of mallards were raising broods, along with several pairs of red-winged blackbirds. I snapped some nice pictures of the courting male blackbirds as they flashed their crimson epaulets. Several killdeers nested on the flats.

My favorite nesting birds in this marsh, though, are the black-necked stilts. The colony that nests here is small—five or six pairs—but the birds make their presence known. Their raucous cries ring out as I enter the field, but they soon forget about me and go about their business as I sit with my camera at the edge of the marsh.

This tiny fragment of wetland is very special to me, a refuge from the bustle of the urban area around me, a place where I can be alone and unbothered as I photograph all the wonderful birds that live here. I prize the pictures I take there as much as or more than those I travel thousands of miles to obtain.

The next time you go looking for a place to photograph birds, remember: Don't overlook the unlikely. You may just find that one of the best locations for photographing birds is right in your own hometown.

The tiny piece of wetland near my home attracts many bird species, but the black-necked stilts are my favorite. I photographed this adult incubating its eggs from a semipermanent blind I set up in the field.

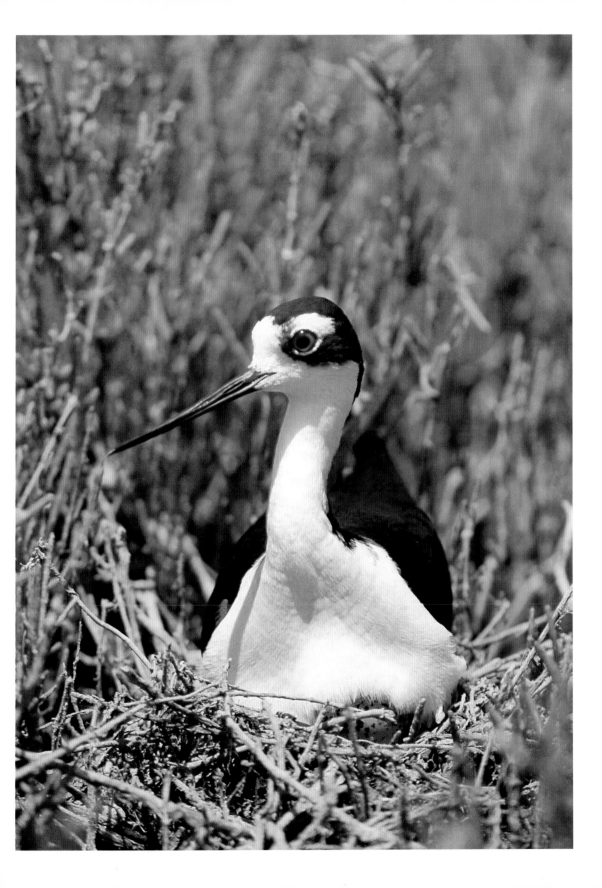

9

THE BIRDER'S EDGE

ANYONE SERIOUSLY INTERESTED in taking up bird photography should also get involved in the related activity of bird-watching. Some people may cringe to read this statement. The term bird watcher or "birder" often conjures up stereotypes of dotty Englishmen in pith helmets or the infamous "little old lady in tennis shoes." Though you may occasionally see people in the field who loosely fit these descriptions, by and large birders today are an incredibly diverse group of people, ranging from poverty-stricken college students, their battered binoculars held together with duct tape, all the way to corporate CEOs, armed with the finest German optics.

By becoming a birder, you'll meet other people with the same interest and learn about bird identification, behavior, seasonal movements, and other information vital to a bird photographer. You'll also find out the locations of all the local bird-watching hot spots. Moreover, you'll be plugged into a grapevine that will keep you informed of any interesting bird species that might show up.

Where I live, in the Cayuga Lake Basin of upstate New York, the local birding club is quite active, and maintains a hotline with a recorded message that you can call twenty-four hours a day to find out about the latest local bird sightings. This information is enormously useful. If an unusually tame northern hawk owl shows up in someone's backyard

near Dryden Lake, I hear about it and can run right over with my equipment. If a snowy owl blows in with a winter blizzard and stops for a couple of days on Mount Pleasant, I'm there within hours to take advantage of the situation.

Our local birding hotline is far from unusual. You'll find hotlines throughout the United States, on a local, state, and national basis. Some hotlines, such as the North American Rare Bird Alert (NARBA), charge a subscriber's fee, but the vast majority are free. For the phone numbers of hotlines in your area, contact a local birding club or Audubon Society branch. You can also call or write to the American Birding Association or the Cornell Laboratory of Ornithology (see addresses in the Appendix); both organizations maintain current lists of birding hotlines.

I particularly like using local hotlines in areas I'm visiting. The statewide or national hotlines tend to list mostly the extreme rarities or vagrants that show up in an area—a fork-tailed flycatcher from South America that ends up on the shores of Lake Ontario; a white-winged black tern from Europe that pairs up with a black tern in upstate New York. Such birds can make great photographic subjects, if you can get anywhere near them. But they invariably draw such huge crowds of bird watchers that there's little chance you'll be able to take a decent picture. A good local hotline will, in addition to announcing rarities, announce seasonal arrivals of more common migrants—colorful warblers, orioles, and so on—and sometimes provide exact locations for some interesting species: flocks of snow buntings and horned larks feeding in a certain farm field; a northern shrike that perches each morning on some bushes near a schoolyard. These kinds of listings rarely draw crowds. You may well find yourself alone with just the birds and your camera. So don't overlook the benefits of using hotlines. They're like having your own army of scouts.

An even more valuable aspect of becoming a birder, however, is the insight you will gain into the lives of birds. You'll learn about their habitat requirements, behavior, territoriality, and so much more, just by spending time in the field both alone and with people more experienced than you. The more time you spend studying birds, the more predictable their actions become, and the easier it is to anticipate a photographic opportunity. For example, you might see a snowy egret

wading quickly around in the shallow water of an estuary. Suddenly it freezes, standing statuelike as it peers down at the water. Chances are that the bird has homed in on a tiny fish swimming around its feet and is waiting for the perfect instant to spring its attack. You frame the shot, recheck the focus, and wait ... five seconds ... ten seconds ... bang! The egret slams its head into the water and comes up with a fish, glistening silver in the morning light. Since you knew exactly what was going to happen, you were ready. You fired off a frame just as the bird splashed its head into the water, another as it pulled the fish wriggling into the air, and still another as the bird gulped down its meal.

As another example, you're sitting in a blind next to a ground-squirrel colony. You know that a local nesting red-tailed hawk hunts here every morning, and you've been hiding in your blind since well before dawn. Through your spotting scope, you can see the hawk distinctly, sitting on a dead branch at the top of a cottonwood tree. As you watch, the bird bobs its head a couple of times, then raises its tail to defecate. Turning quickly away from your scope, you look through your camera and line it up on the squirrel colony. An instant later, a squirrel gives the alarm whistle, then chaos reigns as the hawk slams into the ground, just barely missing a squirrel, then scrambles back into the air and chases another squirrel all the way to its burrow. The bird crashes into the hole a second too late, and now all the squirrels are in hiding.

Meanwhile, you've been snapping picture after picture, from the initial attack to the follow-up, and now you're taking pictures of the hawk gazing longingly into the burrow. You know that not all the pictures will turn out, but the ones that do will be of the most salable kind— shots that capture action or distinctive behavior of a species. And the only reason you were able to get these shots was that you'd spent a lot of time in the field and you know how to read a hawk's body language. You know that a raptor will often bob its head when peering at prey before an attack, and that it will almost always excrete before taking off. You correctly read the signs and reacted instantly, and the yet-to-be developed pictures in your camera will be your reward.

I could go on and on with this, citing examples of how a knowledge of bird behavior would give you advance warning of a potential picture opportunity. The point is that it's more than worthwhile to increase your knowledge of birds; it's a necessity for successful bird photogra-

phy. If you can identify a species quickly and you know how that species generally behaves in a given situation, you're definitely ahead of the game. And it's not that difficult to accomplish. Start by picking up a field guide and trying to identify all the birds you see. Get comfortable at naming your backyard birds, then move on to waterfowl, then shorebirds and gulls and raptors. If you live near a birding hot spot, visit the place as often as you can, with or without your camera. Talk to the birders you encounter. Be inquisitive. Let them teach you. You'll find that most birders are friendly and eager to share their expertise. Everything you learn now will increase your depth of knowledge and skill as a bird photographer.

Read some more advanced guides. *The Birder's Handbook* by Paul Ehrlich, David Dobkin, and Darryl Wheye is an excellent reference, once you get used to the shorthand system they employ. With this book you can find out whether the species nests on the ground, in trees, or on a cliff; what kind of food it eats; and whether the bird's young are altricial or precocial. How can you find a particular bird species if you don't know the kind of habitat it prefers or its typical nest site? How can you expect to photograph young birds if you don't know the rate at

Learn as much as you can about the nesting biology of the particular species you're photographing. For example, young black-necked stilts are precocial—they leave the nest almost immediately after hatching. If you want to get pictures of them at the nest, you better be there when they're hatching.

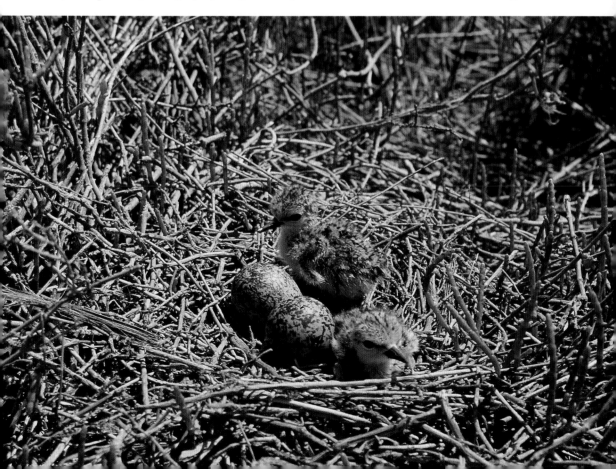

which they develop—altricial young remain in the nest under a parent's close care for days or weeks, while precocial young can walk away soon after hatching. If you're counting on getting shots of precocial young, such as black-necked stilts, soon after hatching, you'd better be ready because they won't wait long for you to snap your pictures.

Also useful is the three-volume set *A Guide to Behavior Watching*, written by Donald and Lillian Stokes. Though the books are somewhat elementary, they do provide useful insights into what birds are signifying with their various songs and calls, body language, and behavior.

In addition to books, I recommend your buying some bird sound guides—cassette tapes or compact disks that provide examples of the vocalizations of particular bird species. "Ear-birding" is definitely a useful skill for a bird photographer to develop. Nonbirders may not realize it, but each bird species has distinctive songs and calls that set it apart from all other species. Though it may take an expert to distinguish between two soundalike species, most people can become fairly proficient at basic birdsong identification by listening to sound guides. Some excellent sound guides for beginning ear-birders are "A Birdsong Tutor for Visually Handicapped Individuals" and "Know Your Bird Sounds," Volumes One and Two, by Lang Elliott; "Birding by Ear" and "Backyard Bird Song" by Richard K. Walton and Robert W. Lawson; and also four tapes by Donald J. Borror: "Common Bird Songs," "Songs of Eastern Birds," "Songs of Western Birds," and "Bird Song and Bird Behavior." National Geographic and Peterson Field Guides have also produced audio guides to complement their bird field guides. As you become more advanced, you may also want to study the "Songs of the Warblers of North America" by Donald Borror and William Gunn.

What good is it to memorize bird sounds? For one thing, it can save you legwork. Imagine that you're looking for the nest of a scarlet tanager to photograph. You think you hear one singing in some woods, so you spend an hour or two tracking down the songster, only to find out that it's the soundalike American robin. If you had spent a little time listening to tapes of the two species, you could have easily distinguished between them. Or perhaps you don't have a clue what a tanager song sounds like. You might walk right past one singing loudly in the forest canopy above you and not even realize it.

By building up a more complete knowledge of bird habitat require-ments, behavior, and songs—by becoming the best kind of birder—it will become much easier for you to find the target species you want to photograph. Say that you want to take pictures of an ovenbird. You'll know from your research that the species usually nests in deciduous woods, and always on the ground in an enclosed, ovenlike structure— hence the name "ovenbird." And from listening over and over to bird-sound tapes, you're familiar with the bird's loud, distinctive song, *teacher, teacher, teacher!* Armed with this knowledge, finding a breed-ing pair of ovenbirds should be fairly easy. The same will also be true of most other bird species that you take the time to learn more about.

When you reach a certain level of expertise, you may want to work as a volunteer on some ornithological research projects. This is a tactic that I cannot recommend highly enough. I've been involved in bird re-search as an amateur since high school and it's been a great learning ex-perience for me. It has also opened many doors. I've worked on prairie falcon studies in both California and southern Canada; I've helped watch Swainson's and ferruginous hawks on the western grasslands; I've trapped and banded migrating peregrine falcons on an island in the Gulf of Mexico.

Besides boosting my knowledge of birds—not just the ones I was studying, but also the other species I encountered in the field—these re-search projects provided unsurpassed picture opportunities. I certainly took some of my best raptor photographs while working as a volunteer researcher. One positive aspect of such work is that you can tag along when the ornithologists check nests to see if they're occupied or to band young birds. This is a great time to take close-up shots of nestlings or of parents defending their nests. Many raptors are aggressive toward humans at the nest, diving repeatedly at intruders. I don't like to both-er nesting hawks just to take pictures, but if scientists are visiting a nest anyway to gather data that they may use to help the species, I have no qualms about going along and documenting the event with my camera. And since the researchers are generally experts on the species that they're studying, they know how to minimize the impact of their nest visit.

How can you find out about volunteer opportunities in ornithology? The American Birding Association (which is a useful organization to

join) publishes an annual listing of volunteer research opportunities for bird watchers. These range from small-scale bird counts to major research programs mounted by universities or government agencies. Some pay stipends and provide food, lodging, and transportation; others expect volunteers to take care of themselves. For a college student taking the summer off, a retired person, or a free-lancer with plenty of spare time, these projects are ideal. And once you've participated in one or two of them, you'll find it's easy to get involved in other projects.

Subscribing to bird-watching magazines is also a good idea. They represent potential markets for your pictures, should you choose to sell them. By looking through these magazines closely, you'll get an idea of the kind of photographs they're after (and also a view of the competition you're up against from other bird photographers). In addition, the magazines will keep you up to date on bird research, equipment, places to visit, and more. In North America alone we have *Living Bird*, *Bird Watcher's Digest*, *WildBird*, *Birder's World*, *Birding*, and *Birds of the Wild*, just to name the major national publications dealing exclusively with birds. Other publications, such as *National Wildlife*, *Audubon*, *Sierra*, and others often publish bird-related articles. I recommend that you buy them, read them thoroughly, and glean whatever information you can from them.

I've spoken quite a bit about concrete, practical reasons for a bird photographer to become an active bird watcher, but there are other reasons. For one thing, if you're far from home on a photographic excursion, what are you going to do when you're not taking pictures? The hours of ideal photography conditions in a day are few—a couple hours in the early morning and late afternoon when the light is soft and the angle of the sun is pleasing, bringing out the rich hues and subtle feather detail of a bird. So how can you keep busy for the rest of the day? The answer, if you're a birder, is to go bird-watching. Time spent in the field studying birds is seldom wasted. You're constantly learning more about bird behavior, you're checking out possible photographic setups for later, and you may just find that you're enjoying bird-watching for its own sake.

I'll never forget seeing a tiny Sprague's pipit flying high over a North Dakota grassland, singing its heart out; or the upland sandpipers I heard above me, their high-pitched, slurred whistle ringing out as they

glided down to a Nebraska field in the early-morning darkness; or the red-necked grebes that laughed eerily around me, courting in the moonlight as I paddled my canoe across a remote lake in Manitoba. If you can appreciate moments like these, even though you'll never be able to take a picture in any of these situations, you have an edge over someone who sees birds only as a colorful photographic subject. You have an appreciation of birds that will help you in other times and places. You know these birds. You understand them and you empathize with them.

Though I'm somewhat reluctant to proselytize for birding, I must say that it can enrich your life in many ways. It's an entry point into nature. Like the fly fisherman who learns about trout behavior, pond and stream life, insect hatches, and the quality of water from practicing his art, a bird watcher can catch a glimpse of a wider universe. Many outdoor activities can provide this, but the combination of bird-watching and photography is particularly effective. Gazing at a bird through a telephoto lens focuses your concentration to an amazing extent. You see the bird relaxing in the soft sunlight, sheltering its eggs, or interacting with its mate, you notice the subtle variation in the colors of the bird's plumage, *and* you gain a sense of oneness with the bird and the entire environment around you. This is the essence of the bird photography experience.

10

THE TRAVELING PHOTOGRAPHER

THERE COMES A TIME in the life of every bird photographer when all the nearby picture-taking locales start to get stale. You sit at home, with a massive heap of expensive camera equipment and color film at your feet. But there's nothing... nothing you really feel like photographing. You've already snapped a thousand shots of every feathered creature that ever flitted through your backyard feeding station. You're such a familiar sight at the city park pond that the ducks strike a pose whenever they see you coming. You've photographed the herons and egrets in the local slough so often that you know them all on a first-name basis. So what are you going to do?

Only one thing I know of will ease the bird photographer blues: pack up all your camera gear and head off in search of greener pastures. Whether you travel across the state or around the world, the combination of new scenery, new habitats, and new birds should provide just the dose of inspiration you need to beat the photographic doldrums.

Before you drop everything and leave on your photographic safari, though, take a little time to plan your trip. The first step is to figure out a place that's worth visiting. Several excellent books have been pub-

lished that tell where to find birds in various areas of North America. All of the Lane guides are useful, though they deal with only a few regions. A couple of my favorite North American bird travel guides are Olin S. Pettingill's *A Guide to Birdfinding East of the Mississippi* and *A Guide to Birdfinding West of the Mississippi*. They contain a wealth of information, not just about hot spots, but also on interesting areas you might pass on the way to hot spots. Oftentimes these secondary locales turn out to be better for photography than the primary destinations. They're rarely as crowded as the popular hot spots, and since you're going to pass them on the way to a hot spot anyway, they don't burn up any more gas to visit. You should visit as many places as possible on a trip to make the most of your travel dollar.

When researching a bird locale, always pay close attention to the time of year the author recommends visiting the place. If you choose a destination best known for the massive numbers of migrant warblers that pass through each spring and fall, it would be a great mistake to go in the dead of winter. Hawk Mountain may be one of the top raptor-watching locales on this continent, but if you go at the wrong time of year, you won't see many hawks.

Find out as much as possible about the area you intend to visit. You need to know the kinds of birds you'll be photographing and what habitats they exist in. This helps in your choice of equipment and clothing. For example, if you'll mainly be photographing waterfowl, you might want to take along some high-top rubber boots or even chest-waders so you can get out where the birds are. You may be able to call or write to a sanctuary headquarters or a local chamber of commerce to obtain more information before you visit an area.

A dependable, well-tuned car or truck is an absolute necessity for a safe driving trip. The last thing you want is to leave a car broken down on the side of the road with a load of expensive camera gear locked up inside it. Even if your equipment is hidden from sight in the trunk, you're taking a big chance.

You may want to insure your cameras and lenses. Talk to your insurance agent. Many companies will cover your equipment, usually by adding a special rider to your homeowner's or renter's insurance. But even if you do insure your equipment, be sure to take precautions against theft. Losing your camera gear will put an abrupt halt to your

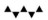

trip, even if you *are* reimbursed later. Always keep your cameras well hidden when they're not in use. If you stop to eat in a restaurant along the way, park where you can keep an eye on your car. If you stay in a hotel or motel, *never* leave your equipment in the car overnight. It only takes a minute to carry your cameras into your room.

You should also take special care of your film. It is easily damaged by heat. I always take a small ice chest along with me on driving trips. I store the rolls of film in a waterproof plastic container in the ice chest to protect them from moisture. A couple of hours before I expect to use a roll of film, I take it out so it can warm up gradually to room temperature. After shooting the film I return it to the ice chest.

Develop film as soon as possible after it's exposed, especially if it's professional film. I'm usually reluctant to take film to a local processing lab in an area I'm visiting, however. Most small town photography shops send their slide film away to be developed, sometimes to a processing lab in another state or province. You might get hung up for days waiting for your film to arrive. I usually either buy prepaid processing mailers and send my exposed film immediately to a mail-order lab, such as Kodalux or Fuji, or I just keep the film in my ice chest until I can take it to my regular lab back home.

Think carefully about the equipment you'll need to take along. You want to take all the necessary items with you, but you don't want to take too much. Unnecessary equipment is a major nuisance on a trip. I pack relatively lightly. I usually bring at least two camera bodies in case one of them malfunctions. If possible, three or four are even better. They really don't weigh much or take up a lot of space. For lenses, I take along a good zoom lens in the 28–80mm range for scenics and habitat shots, a telephoto zoom in the 70–200mm range for the intermediate shots, and a 400mm telephoto for full-frame shots. I also bring a 1.4× teleconverter, which boosts the focal length of my 400mm lens to 560mm. And of course I wouldn't go anywhere without a tripod.

A word about extra batteries for your cameras and strobes: Don't leave home without them. Batteries have an uncanny way of going out at the worst possible times. If you're out in the bush, miles from civilization, you may not be able to replace them. Having a few spares in your camera bag will, if nothing else, keep your mind at ease.

Make your photographic equipment as accessible as possible on a

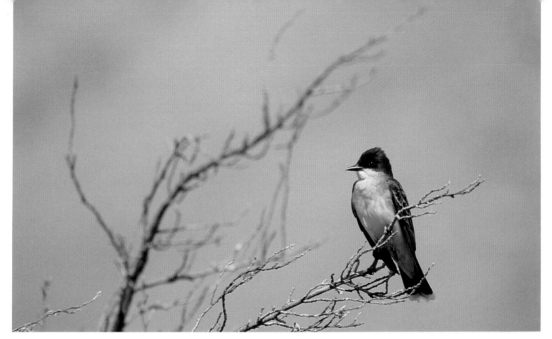

I found a nesting pair of eastern kingbirds while I was driving through western Canada. The off-center placement of the main subject and the diagonal lines of the branches made this picture a more interesting composition than it would have been if the bird had been placed dead center.

driving trip. I always know where every lens is located so I can get to any of them immediately if an unusual photographic opportunity comes up. "Be prepared" is the motto when you're traveling. You'd be surprised how often interesting birds pop up on trees and fences along the highway. If you're ready, you can take full advantage of the situation.

I usually carry a loaded camera with a telephoto lens on the seat next to me while I'm driving through good habitat. If I see something interesting up ahead, I quickly roll down the window, turn off the engine, and coast to a halt near the would-be subject (this is not a good idea if you have power steering and brakes). Resting the camera on a beanbag placed on the window sill, I can usually take a couple of pictures before the subject spooks. I've photographed everything from moose and elk to Swainson's hawks and upland sandpipers this way.

Perhaps a driving trip in North America will not be enough to get you excited about photography again. In that case, you'd better renew your passport and get your shots updated. It's time to fly away to a far-off overseas locale to photograph birds. Nothing's quite like it for shaking off the cobwebs. Everything is so fresh and new—the people, the

scenery, and of course, the birds. No matter where you travel on this planet, you're sure to find inspiring new horizons for practicing the art of bird photography.

Before you leave on your trip to Africa, Asia, Europe, or any other dream location, however, you should be aware of some of the pitfalls of traveling with expensive camera equipment. Theft is one of the greatest dangers. Camera equipment is fairly light and easy for a thief to conceal. It can also be converted quickly to cash on the black market.

You can take precautions to guard against theft. For one thing, avoid packing your equipment in an easily recognizable camera bag. Bags with camera brand names plastered all over them may look attractive, but you might as well have a flashing neon light saying: "Expensive camera equipment inside." I prefer to carry my gear in a nondescript backpack.

Avoid checking your most valuable camera gear in at the baggage counter. I may slip a tripod and a couple of strobes into my luggage, but the cameras and lenses go with me as carry-on items. It's just too easy for a dishonest baggage handler, another passenger, or a passerby to snatch your bag if they suspect it contains expensive equipment. And many airlines don't insure camera gear at all, or they require you to pay an additional fee for the coverage. If you must check in your camera, you should at least find out if the airline will replace it in the event of loss or theft.

Airlines always allow passengers to take on one or two items of hand luggage, which can be stowed under the seat or in the overhead compartment. This is the only way to go if you want your gear to be really safe in transit. Even a huge super-telephoto lens will fit into hand luggage.

I always carry expensive and difficult-to-replace items with me in my hand luggage; less expensive and easily replaced items can be checked in with the airline. Remember, you can get a new tripod or strobe for a reasonable price just about anywhere in the world, but losing a $5,000 telephoto lens would end your photographic excursion immediately.

Once you arrive at your lodging, avoid leaving your camera equipment out in your hotel room. Check with the room clerk. The hotel might have a safe where guests can leave jewelry and other valuables. If

your equipment is not too heavy or bulky, though, you might be better off carrying it with you.

Another consideration when transporting equipment overseas is the process of getting your camera gear through U.S. Customs without having to pay duties upon your return home. It's easy to see how a customs inspector might get suspicious when someone arrives from Japan carrying $5,000 worth of Japanese-made camera equipment. You must be able to prove that you bought your equipment in the United States and that it is not subject to import tariffs. The best way to avoid hassles with U.S. Customs is to declare all your equipment before you leave the country. Most international airports in the United States have an office or window you can visit for this purpose. Call the U.S. Customs office at your closest international airport for more information.

X-ray damage to your film can be a problem these days, as airports around the world attempt to deal with the threat of terrorism. Usually running film through the airport security X-ray devices once or twice will not cause any problems. However, if your film is exposed to X-rays four or five times, there might be noticeable fogging in your pictures.

At most airports in the United States, security personnel will inspect your camera gear and film by hand if you request it. It's another story overseas; too many European airports have been struck by terrorist attacks. Security personnel there tend to be unsympathetic when you complain about putting your film through the X-ray machine.

To avoid the problem, I pack my film in special lead-lined bags (available at most camera stores). These show up as formless black shapes on the X-ray screen. After the bag goes through the machine, the security guard will want to hand inspect the contents of the lead-lined bag, which is all I would have wanted in the first place.

To make the inspection quicker and easier, I remove the 35mm film cassettes from their packaging and place them loose inside a Zip-lock bag, which is in turn placed inside the lead-lined bag. That way, the guard can take a quick look and see that the bag's contents are harmless.

Some people try to avoid having their film X-rayed by placing it inside their check-in baggage. This is a mistake. Almost all check-in baggage goes through an X-ray machine before it's loaded onto the plane, and they're usually much more powerful than the machines at the departure gates.

Once you've reached your destination, you may find that it's not as easy as you thought it would be to take close-up photographs of birds. In Europe especially, many of the refuges and sanctuaries keep the public well away from the birds. Birders there depend on their binoculars and spotting scopes to identify birds at a distance, but photography is almost impossible. To overcome this problem, I always look for other more accessible areas in the vicinity of wildlife sanctuaries. Farmland, sloughs, roadside ponds, and windbreak trees can all provide great locales for bird photography. Also, try looking in city parks or in the elaborate gardens found around palaces and estates, many of which are open to the public.

I once found a pair of Eurasian kestrels nesting in the ornate stonework of an Austrian palace. I took a number of photographs of the birds flying in and out of this picturesque site. On the same trip, I photographed white storks nesting on rooftops in the town of Rust, Austria. At first I had a problem getting into the right position to photograph the birds. I didn't like the angle shooting from below. I finally climbed up into the tower of the village church and shot pictures of the birds nesting on the surrounding rooftops.

Part of the challenge of any foreign excursion is in overcoming the obstacles presented by the different languages and customs of the people in the places you visit. If you are friendly and open about what you want to do, though, you'll usually find people willing to go out of their way to help you.

I strongly recommend taking an overseas trip to photograph birds. You'll find birds and scenery unlike anything you've ever seen at home. All you need is a good camera, plenty of film, and an adventurous spirit.

11

BASIC CAMERA CARE

FEW ACTIVITIES ARE as potentially damaging to cameras as bird photography. On desert excursions, cameras face intense heat as well as wind-blown dust and grit that have a way of getting through the tightest seams in a camera bag. On journeys to marshes, cameras get dragged through muck and slime as an avid photographer tries to crawl a little bit closer to an elusive bird. But the worst of all are pelagic birding trips, when cameras are misted constantly with fine salt spray—the most corrosive substance they're ever likely to come in contact with. Whenever your camera has been around salt water, clean it as soon as possible. Salt water will start to pit and corrode a camera after only a few hours of contact.

You may think it's a losing battle to fight the ravages of the elements on your camera; however, you can take precautions to keep your photographic gear functioning year after year. The main thing is to inspect your equipment frequently. You can do this yourself during and after birding trips. It takes surprisingly little time to wipe off your camera, and it's well worth the effort.

Whenever I'm on an extended photographic trip, I always give my equipment a quick once-over at the end of the day. If it looks damp or excessively dirty, I take the time to clean it off. I wipe off any dust, grime, or moisture, and put it away in a clean, dry place. My care has

paid off; my equipment tends to last a long time. One of my cameras is over twenty years old and still works perfectly.

Carry a small can of WD-40—a powerful moisture eliminator—along on photographic trips. Spray a tiny amount on a clean rag, then wipe it gently onto the metal areas of your camera and lens. This will form a thin protective coating of silicone, providing a degree of protection from moisture. However, never allow any WD-40 to get on any glass surfaces, such as the lens element or viewfinder. It will leave a smeared coating on the glass that's be hard to get off. Also, never spray WD-40 directly onto your camera body, or you'll end up with a slimy mess.

Get into the habit of cleaning your camera thoroughly at the end of a trip, or whenever you plan to store it. To begin the cleaning, remove any outside dirt and grime with a soft cloth or a piece of chamois. You can use an old toothbrush or Q-tips to get to hard-to-reach places. When the exterior is spotless, take off the lens and open up the back of the camera. Carefully remove any torn bits of film or dirt. Blow out any interior dust with canned air or with one of the combination blower-brushes. These handy products are available at most camera stores. Do not use your breath to blow out a camera. This will inevitably leave unwanted moisture in the camera. Also, never clean the mirror unless it's absolutely necessary; it's too easily scratched. If your mirror must be cleaned, be very careful. Wrap some lens tissue around a Q-tip. Dampen the end of it lightly with lens-cleaning fluid and carefully swab the mirror. You can also do this to your viewfinder and focusing screen if necessary.

When you're finished with the camera body, set it to one side and pick up your lens. Always lightly blow the grit and dust from the surface of your lens with compressed air before cleaning the glass. If you use a tissue first, grit on the lens might scratch the glass. Squeeze a few drops of lens-cleaning fluid onto a piece of lens tissue, then wipe it gently over the lens element. Then take a clean piece of lens tissue and remove the fluid before it dries; otherwise it might streak the lens. Never pour the lens-cleaning fluid directly onto the lens; it will make a mess and might even get inside the lens and cause damage. Use only lens-cleaning fluid made specifically for cameras. Eyeglass-cleaner will leave a coating of silicone on the lens.

If you don't have one in place already, now would be good time to install a UV filter on the end of your lens to protect the front element. Filters are relatively inexpensive to replace if they become marred or scratched; prime lenses are not. For additional protection, always keep a lens cap on the lens when you're not using it.

The next step in the cleaning process is to remove the batteries from your camera. If you find any oxidation on the batteries or battery holder, they must be cleaned off thoroughly. Use a pencil eraser to clean the batteries and contacts, then wipe them with a soft tissue. Avoid touching the batteries directly with your fingers. The moisture on your skin can promote corrosion. (This is a good time to see what kind of shape your batteries are in if you have a battery tester.) If you don't plan to use your camera for several months, take the batteries out of your camera and store them separately. Be sure to keep an accurate record of when you install new batteries. If batteries have been in the camera for over a year, you should consider replacing them, even if they're still functioning well. Old batteries can quit without warning, leaving you with a nonfunctioning camera or light meter at a crucial time. Always carry spare batteries on a trip.

Some plastic Zip-Lock food storage bags are useful for camera protection. You can seal your camera up inside one while traveling in areas where fine dust, grime, or moisture are problems. Just take your camera out when you need it, then wipe it off immediately and seal it safely back inside the bag. Always throw one or two packets of silica gel in the plastic bag with your camera to absorb trapped moisture.

You can also make a simple camera raincoat from a Zip-Lock bag. Just put it upside down over the camera, then cut holes at each end to accommodate the lens and viewfinder. Use rubber bands to hold the plastic bag snug around the lens. Your hands can reach up from the main opening below to operate the camera controls. This inexpensive cover provides a surprising amount of protection from adverse weather.

Photographers who work in cold climates have still another use for Zip-Lock bags. Before going into a warm house during freezing weather, they place their cameras into plastic bags, squeeze out all the air, then seal the bags. This prevents moisture from forming on the camera as the warm, damp air in the house hits the cold metal of the camera and condenses.

Before ending this chapter, a few more don'ts are in order. Unless the problem is something very basic, never attempt to repair your own camera. Cameras are much too valuable and easy to damage to be worked on by an amateur repairman. Never lubricate your camera or lenses. This, again, should be done only by a qualified camera repairman with the correct lubricants and a knowledge of how to use them. Never touch your camera's mirror, or you'll leave smudges and fingerprints. And never touch the shutter curtain; it's extremely delicate.

Bird photography is not likely to get any easier on camera equipment, but by following the procedures in this chapter you can effectively immunize your camera against some of the most destructive elements it will face.

12

SELLING YOUR BIRD PHOTOGRAPHS

SEEING YOUR PICTURES published definitely adds a rewarding extra dimension to bird photography. Besides the money you can earn to buy more camera equipment and film, you'll have the pleasure of sharing your work with other people with a similar interest in the beauty of birds. But to be successful you must first thoroughly research the potential markets for your work and then put together an editor-friendly package that will get the attention it deserves.

In the competitive world of nature photography, it is vitally important to give yourself an edge. Literally hundreds of able nature photographers are out there, all vying to have their work published. The more a magazine pays for photographs and the more prestigious the magazine is, the more and the better the photographers are who will be submitting their pictures. What can you do to make your work stand out from the rest? Most importantly, you must produce first-rate images. But beyond that you must also figure out the kinds of photographs individual magazines are looking for, and tailor your submissions accordingly.

A good way to break in as a bird-magazine photographer is to submit a series of pictures taken at a birding hot spot. This could be a

wildlife refuge, a national park, a seashore—anywhere that a bird watcher would be interested in visiting. Travel articles are a staple of most bird magazines. *Birder's World* has a "Birding Hot Spots" department; *WildBird* has "Birder's Guide" features; *Living Bird* has a "Wanderlust" column. They're always looking for new places to cover. Look at some back issues. Get a feel for the type of shots they publish in their travel articles, then visit a local refuge or other appropriate locale.

Where do you begin when you get to your photographic destination? Let's say that the place is a wildlife refuge: Start by taking some shots of the entrance gate, the sign, and the headquarters building. I know these are boring pictures to take, but a magazine will often pay just as much to run one of these as they would for a close-up shot of a bird that you spent weeks in a blind to obtain. So swallow your pride and take the shots; they help pay for more film and equipment.

If the refuge has a nature center, go inside and take some flash shots of any interesting displays you see. Try to get pictures of people looking at the displays. Go to the main office and introduce yourself. If you have any clips of your published photographs or articles, show them around—they will definitely open doors for you. Talk to a ranger, a biologist, or someone else who works there. Find out what's going on at the refuge. Are they conducting any bird research? Are they doing anything to improve the quality of the environment? By talking to the people in charge, you may get ideas for other articles in addition to the travel feature. You may also find that a ranger or a biologist will take you on a behind-the-scenes tour of the refuge and perhaps give you special access to closed areas where you can take pictures. This has happened to me again and again. I've been taken around in pickup trucks, air boats, and small planes, and shown all the best sites for bird photography.

The main thing to strive for when visiting a refuge or another birding locale is to get full photographic coverage of the place. Take close-up portraits of the birdlife if you can, but also back off a little and get shots of the birds in their habitat. Take some wide-angle scenic pictures of the entire ecosystem. And don't forget about the people. If you see some birders standing on a boardwalk or tower, snap a few shots of them. These pictures are easy to take and highly salable to bird magazines. If you are lucky enough to be taken on a grand tour of the place

by refuge staffers, be sure to take pictures of any field biologists involved in bird-related research. You may not be able to sell all of these shots, but it's important to provide the most complete package you can to a magazine.

As I've said before, understanding birds is a vital part of bird photography; but if you intend to sell your pictures to magazines, it's also important to understand editors. Having worked on both sides of the fence—as a freelancer and as an editorial staffer on several magazines—I have some special insights into the inner workings of an editor's mind. One thing to keep in mind is that editors want your submissions to be great. For an editor, nothing's better than opening up a package from an unknown contributor and finding the magazine's next cover shot or photo essay. It's especially great if a well-written manuscript accompanies the photographs. That's a dream come true for an editor—a complete article package ready for placement in the next issue. What could be easier?

If in addition to having good photographic skills you can also write well, you have a definite advantage when it comes to getting your work published. Otherwise, you might have the greatest pictures in the world of a particular place or bird species, but unless they're run as a photo essay, an editor will have to find someone to write an article to accompany your shots. That means extra work for the editor.

If you don't feel confident in your ability to write an article, try to team up with a good writer. Call journalism departments at local colleges and universities and see if they can recommend a promising student. Or talk to people at birding clubs. A surprising number of bird watchers are excellent writers. You may be able to develop a productive partnership—you supplying the photographs, the other person writing the text of articles you produce together. Such a partnership will definitely increase the chances of being published for both of you. You'll also be able to split expenses when you travel together.

After you've amassed a number of excellent bird photographs, the next step is to find someone who wants to publish them. Numerous markets exist for bird photographs—magazines, book publishers, calendars, greeting cards, ad agencies, stock photo agencies, and more. Both *Writer's Market* and *Photographer's Market* contain annually updated lists of agencies, publishers, and others who buy photographs.

You'll find these helpful guides at most bookstores and libraries, providing a valuable resource for freelancers. Look at the listings under appropriate headings—nature, animals, photography. You should find several publishers who frequently use pictures of wild birds.

Before contacting publishers or submitting photographs, familiarize yourself with their products. If they publish a magazine, buy a copy and study it thoroughly. I can't overemphasize how important it is for photographers and writers to be thoroughly familiar with a magazine before submitting their work. You'd think that would be obvious, but it always surprises me how many completely unsuitable photographs I receive as an editor, and that's been true everywhere I've worked. At both *Living Bird* and *WildBird* magazines, people have sent me hundreds of pictures of domestic fowl—pigeons, chickens, geese—as well as various cagebirds, such as parrots and macaws. They could have saved themselves time, effort, and the cost of postage just by looking through an issue of these magazines. Pictures of captive birds are rarely published in either of them.

Another good way to familiarize yourself with a magazine's photographic needs is to ask for a copy of its "Contributor's Guidelines." These are usually available free for the asking if you send an SASE (self-addressed, stamped envelope). Some magazines have separate guideline sheets for writers and photographers. I recommend asking for both if they have them. The guidelines spell out in detail the things you need to know about a publication—the desired size and subject matter of the photographs, how much is paid for each shot, the terms of the sale. Armed with this information, you're ready to move to the next step: putting together a sample selection of photographs.

At this point, don't try to impress a photo editor by sending in an enormous number of photographs. Instead, edit your collection down to the bare bones. Select only the highest quality photographs you possess. If you only have five or six fantastic images, then just send them. Who knows? The editor might be intrigued and think that you must have thousands more excellent photographs like these.

Don't be tempted to add fifty or sixty lesser slides to fill out your submission. The great slides might be missed by a busy editor, who takes a quick glance through your photographs and then moves on to the next submission in the stack. Remember, most editors simply do

not have time to pore carefully over each and every one of the thousands of unsolicited photographs they receive.

When you look through your slide selection, be your own photo editor, and be a critical one. Purchase an 8× loupe (magnifier) from a camera shop. If you have access to a light table, use it. Really scrutinize your images. As you look closely at each one, ask yourself: Is this photograph really good enough for publication? If the image is too soft, too light, too dark—if it's at all less than excellent, then don't send it to a magazine. It will only diminish the overall effect of your submission. The best transparencies will be sharp, with good density, and will capture your subject engaged in characteristic behavior—feeding, preening, courting, caring for young.

Never underestimate the importance of packaging when you submit photographs. First impressions are important. The overall appearance of your package definitely affects how closely an editor looks at your pictures. If it doesn't look like the work of a professional, the submission may not be taken as seriously as perhaps it should be. Keep in mind that the appearance of your package says a lot about you. If you send a messy-looking envelope, filled with loose slides that fall out when it's opened, it won't make you very popular with the editor who receives it. At the very least, it gives a bad initial impression, which you then must overcome. It's much better to turn in a clean, tidy package with everything neatly labeled and arranged. The editor will certainly be in a more pleasant frame of mind while reviewing your pictures.

Always place your slides in clear plastic protective sheets. Available at most camera stores, they're inexpensive and provide excellent protection for your valuable transparencies. Twenty 35mm slides fit in each sheet. For even greater protection you can place each slide in an individual plastic sleeve before inserting it in the protective sheet. An editor or art director can place the slide sheet on a light table, scan the twenty transparencies quickly to look for usable photographs, and then use the loupe to magnify any especially interesting images. This kind of presentation makes evaluating a photographer's work quick and easy.

In addition, placing your slides in plastic sheets tells an editor that you value your photographs enough to protect them. If the slides are packed loosely in a battered envelope, or wrapped in Kleenex (I once

received a submission packed that way), it shows that you're not very concerned about your work. So why should anyone else be concerned? Sending slides in the small boxes that come back from the lab is also a bad idea, because this kind of packaging causes extra work for the magazine staff. Each slide must be picked up individually by hand to be viewed. Most editors don't have the time or inclination to do that for you. Make it easier on them and they will most likely make it easier on you when it comes to publishing your photographs.

Once you've chosen your best slides, label each of them plainly with your name and address, number them for identification purposes, and then place them in the plastic sheets. Sandwich the sheets between two pieces of stiff cardboard to provide further protection during shipping. The pieces of cardboard can be held together with a couple of big rubber bands or with strips of masking tape. Then place the whole thing inside a large manila envelope (or use one of the sturdy cardboard envelopes available at most stationery shops). Paste a mailing label on the front of the envelope with the magazine's name and address typed on it. Be sure to have your return address plainly marked on the envelope. In addition (and this is important), include a large self-addressed manila envelope inside the package, with enough stamps to cover return postage.

It's always a good idea to send your photographs by certified mail so that the post office has a record of their delivery. I also usually pay the small amount extra for a postal return card, which is signed by the person who receives the package, handed back to the postman, and sent immediately back to me. I sometimes use Federal Express or United Parcel Service to deliver my photographs. They seem faster and more efficient than the U.S. Postal Service, but are also more expensive.

If you're concerned about your irreplaceable original slides becoming lost in the mail or misplaced by a magazine, you may want to send duplicates. Some labs offer reproduction-quality duplicates for a reasonable price, but they are never quite as good as the originals. Duplicates tend to be grainier and more contrasty. My advice is to have duplicates made of your best slides, then examine them closely. If they look reasonably good, send them to the editor; however, be sure to mention in your cover letter that the originals are available if they are chosen for publication.

Remember to enclose a shipment description with your name and address, and the number of slides or prints being submitted. Send one copy with your photographs and keep another copy for your files. An accurate shipment description simplifies record-keeping for you *and* the magazine staff. Some photographers list the terms of their submission—such as how much the magazine must pay if an image is lost or damaged, and how long images can be kept before a holding fee is charged—on an accompanying sheet. I don't recommend this, though, especially for a newcomer to the field. They are not legally binding documents. Most magazines print disclaimers in every issue that they are not responsible for lost manuscripts and photographs. If you enclose a sheet stating that each slide lost or damaged will cost a magazine $1,500, many editors will return your photographs at once rather than sign such a document. Most reputable magazines do take great pains to protect your photographs.

Include a brief introductory letter with your submission, stating, more or less, that you're a freelance photographer interested in having your work published in the magazine. If you have any kind of track record—you've been published previously in magazines or newspapers—it's definitely worth mentioning, particularly if they were prominent publications. You might even include a résumé if you have a substantial background as a professional photographer. Send a list of your photographs if your collection is extensive enough to warrant it.

Are you proposing to write an article to go with your photographs? If so, be sure to include a one-page, typewritten query letter explaining your article idea in detail. (If you've teamed up with a writer, that person should write the letter.) Some editors prefer to receive a query letter first, even if a writer has a finished manuscript. Check the magazine's guidelines. If they don't say "Query first," then go ahead and enclose the complete manuscript with the photographs.

Before you send off your photographs, let me offer a short word of caution: Make sure you know exactly what rights to your photographs you are giving up. Most magazines buy only one-time rights to a photograph. All subsequent rights revert back to the photographer after publication. That arrangement usually works out best for freelance photographers, because the image can be resold again and again. Some publishers, however, buy "all rights" to a photograph. According to

those terms a photographer loses all future revenues a particular image might earn. If the photograph later ends up plastered on billboards from coast to coast as part of a million-dollar ad campaign, you get nothing more. Selling all rights is not necessarily all bad if you're paid enough to make it worthwhile. But you should know up front exactly what kind of deal you're being offered.

Now all that's left is to drop your submission off at your local post office and then start the long wait. It may take six to eight weeks or even more before you receive a reply. Don't despair. The fact that your photographs are being held for a long time may well mean that they're being seriously considered for publication. Don't be shy about submitting your work to publishers. If the photographs are good and you present them in a professional manner, your work is bound to be noticed.

APPENDIX

BIRD MAGAZINES

Birder's World
44 East 8th Street
Suite 410
Holland, MI 49423

Birding
4 Swallow Drive
Colorado Springs, CO 80904

Birds of the Wild
250 Cochran Drive, Unit 4
Markham, Ontario L3R 8E5
Canada

Bird Watcher's Digest
P.O. Box 110
Marietta, OH 45750

Living Bird
159 Sapsucker Woods Road
Ithaca, NY 14850

WildBird
3 Burroughs
Irvine, CA 92718

GENERAL NATURE MAGAZINES

Audubon
700 Broadway
New York, NY 10003-9501

National Geographic
17th and M Street NW
Washington, DC 20036

National Wildlife and
International Wildlife
8925 Leesburg Pike
Vienna, VA 22184-0001

Natural History
Central Park West at 79th Street
New York, NY 10024

Sierra
730 Polk Street
San Francisco, CA 94109

PHOTOGRAPHY MAGAZINES

Nature Photographer
P.O. Box 2037
West Palm Beach, FL 33402

Outdoor Photographer
12121 Wilshire Boulevard,
Suite 1220
Los Angeles, CA 90025-1175

Outdoor & Travel Photography
1115 Broadway
New York, NY 10010

PHOTOGRAPHY EQUIPMENT

Adorama
42 West 18th Street
New York, NY 10011

Camera World of Oregon
500 S.W. 5th Avenue
Portland, OR 97204

George Lepp and Associates
P.O. Box 6240
Los Osos, CA 93402

Gould Trading
7 East 17th Street
New York, NY 10003

Leonard Rue Enterprises
138 Millbrook Road
Blairstown, NJ 07825-9534

BIRDING SUPPLIES

The Crow's Nest Birding Shop
159 Sapsucker Woods Road
Ithaca, NY 14850

RECOMMENDED PHOTOGRAPHY BOOKS

Fitzharris, Tim. *The Audubon Society Guide to Nature Photography.*
Boston: Little, Brown & Co., 1990.

Kreh, Lefty. *The L. L. Bean Guide to Outdoor Photography.*
New York: Random House, 1988.

MacDonald, Joe. *The Complete Guide to Wildlife Photography.*
New York: Amphoto, 1992.

FIELD GUIDES AND OTHER BIRD BOOKS

Bent, Arthur Cleveland. *Life Histories of North American Birds* (21 vols.).
New York: Dover Publications.

Buff, Sheila. *Birding for Beginners.* New York: Lyons & Burford, Publishers,
1993.

Connor, Jack. *The Complete Birder.* Boston: Houghton Mifflin, 1988.

Ehrlich, Paul, David Dobkin, and Darryl Wheye. *The Birder's Handbook.*
New York: Simon & Schuster, 1988.

Kaufman, Kenn. *Advanced Birding.* Boston: Houghton Mifflin, 1990.

Kress, Stephen W. *Bird Life: a Guide to the Behavior and Biology of Birds.*
New York: Golden Press, 1991.

Peterson, Roger Tory. *A Field Guide to the Birds of Eastern and Central
North America.* Boston: Houghton Mifflin, 1980.

Peterson, Roger Tory. *A Field Guide to Western Birds.* Boston: Houghton
Mifflin, 1990.

Pettingill, Jr., Olin Sewall. *A Guide to BirdFinding East of the Mississippi*. New York: Oxford University Press, 1977.

Pettingill, Jr. Olin Sewall. *A Guide to BirdFinding West of the Mississippi*. New York: Oxford University Press, 1981.

Robbins, Chandler S., Bertel Bruun, and Herbert S. Zim. *Birds of North America*. New York: Golden Press, 1983.

Scott, Shirley L. *National Geographic Guide to the Birds of North America*. Washington, D.C.: National Geographic Society, 1987.

Stokes, Donald and Lillian. *A Guide to Bird Behavior* (Vols. I, II, & III). Boston: Little, Brown & Co., vol. 1, 1979; vol. 2, 1983; vol 3, 1989.

BIRD-SOUND RECORDINGS

"Backyard Bird Songs" by Richard K. Walton and Robert W. Lawson

"A Birdsong Tutor for Visually Handicapped Individuals" by Lang Elliott

"Bird Songs and Bird Behavior" by Donald Borror

"Birding by Ear" by Richard K. Walton and Robert W. Lawson

"A Field Guide to Bird Songs of Eastern and Central North America" by Cornell Laboratory of Ornithology

"A Field Guide to Western Bird Songs" by Cornell Laboratory of Ornithology

"Know Your Bird Sounds" (Vols. I & II) by Lang Elliott

"National Geographic Society's Guide to Bird Sounds" by Cornell Laboratory of Ornithology

"Songs of Eastern Birds" by Donald Borror

"Songs of Western Birds" by Donald Borror

"Songs of the Warblers of North America" by Donald Borror and William Gunn

BIRDING AND WILDLIFE ORGANIZATIONS

American Birding Association
4 Swallow Drive
Colorado Springs, CO 80904

Cornell Laboratory of Ornithology
159 Sapsucker Woods Road
Ithaca, NY 14850

National Audubon Society
700 Broadway
New York, NY 10003-9501

National Wildlife Federation
8925 Leesburg Pike
Vienna, VA 22184-0001

Sierra Club
730 Polk Street
San Francisco, CA 94109

INDEX

INDEX

137